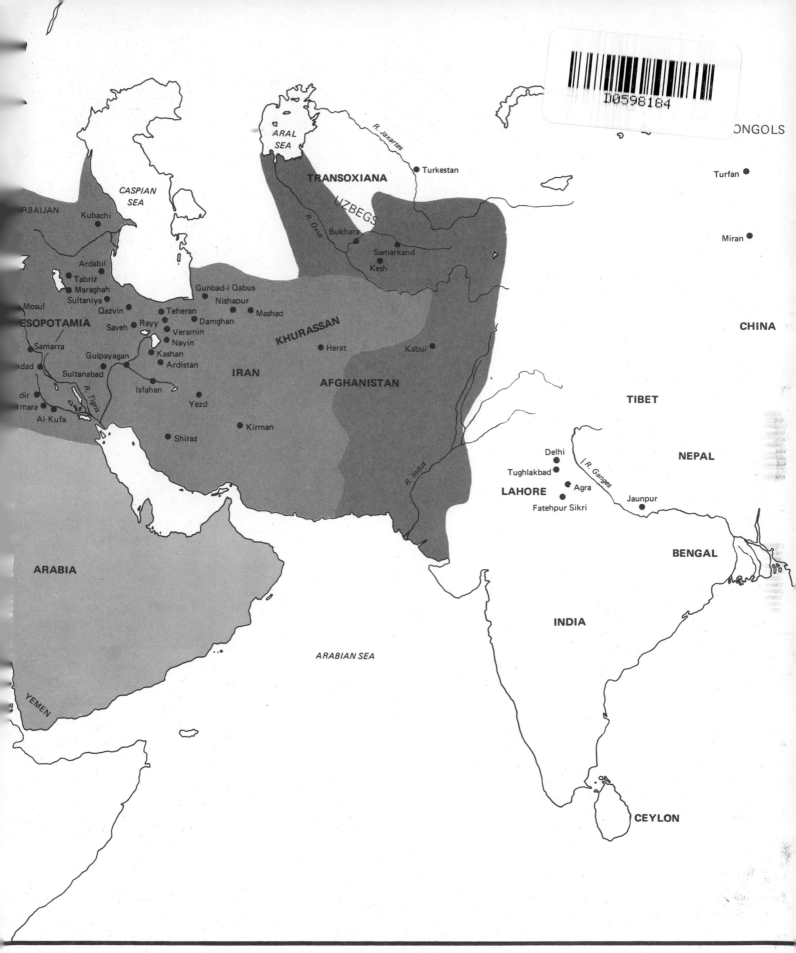

ONGOLS

Turfan •

Miran •

CHINA

TIBET

NEPAL

BENGAL

INDIA

CEYLON

ARAL SEA

TRANSOXIANA

UZBEGS

• Turkestan

R. Jaxartes

R. Oxus

Bukhara

Samarkand

Kesh

CASPIAN SEA

RBAIJAN

Kubachi

Ardabil

Tabriz

Maraghah

Sultaniya

Mosul

Qazvin

Teheran

Saveh Rayy

ESOPOTAMIA

Veramin

Samarra

Nayin

Gulpayagan

Kashan

dad

Ardistan

Sultanabad

dir

Isfahan

mara

Al-Kufa

R. Tigris

Gunbad-i Qabus

Nishapur

Damghan

Mashad

KHURASSAN

Herat

Kabul

IRAN

AFGHANISTAN

R. Indus

Yezd

Kirman

Shiraz

Delhi

Tughlakbad

LAHORE

Agra

Fatehpur Sikri

R. Ganges

Jaunpur

ARABIA

YEMEN

ARABIAN SEA

 Conquests under the first Caliphs 632-661 AD

Conquests under the Umayyads 661-750 AD

Islamic Art
An Introduction

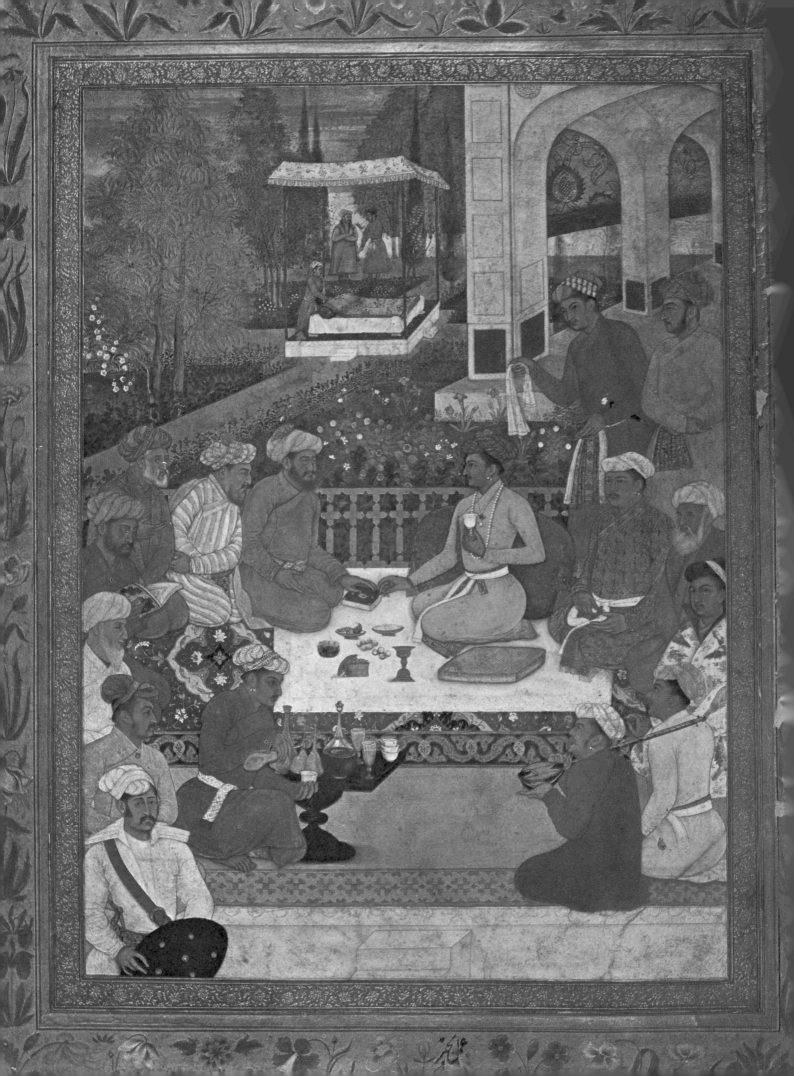

Islamic Art
An Introduction

David James

Curator of Islamic Art
The Chester Beatty Library, Dublin

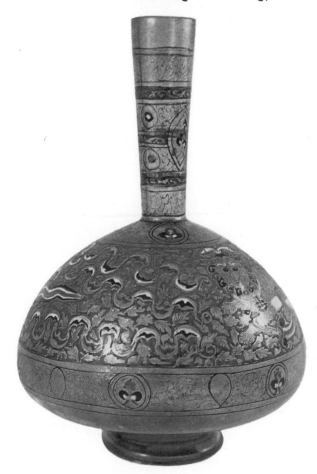

Hamlyn

London · New York · Sydney · Toronto

frontispiece
1 Painting showing a Mughal prince in a garden, Mughal India. $15\frac{1}{4} \times 10\frac{1}{2}$ in. Chester Beatty Library, Dublin. This comes from one of the albums made for the Emperor Jahangir (1605-1627), and shows the extent to which Mughal painting diverged from that in the rest of the Islamic world. The high-horizon format gives way to real space and a form of perspective is introduced, though not the focused system of Western art in which an artificial vanishing point is employed. The features are genuine portraits and the still-lifes rendered with scientific accuracy. This is the work of Bichitr, one of the finest portrait painters.

title page
2 Enamelled glass bottle, Aleppo, Syria, 14th century. Height $15\frac{3}{4}$ in. Calouste Gulbenkian Foundation Collection, Lisbon. Excellent enamelled glass was made in Syria during the 13th and 14th centuries. Like much of the later Mamluke decoration this piece shows strong Far Eastern influence.

1 Published by
The Hamlyn Publishing Group Limited
London · New York · Sydney · Toronto
Astronaut House, Feltham, Middlesex, England
©Copyright
The Hamlyn Publishing Group Limited 1974
ISBN 0 600 34854 7
Phototypeset in England by
Filmtype Services Limited, Scarborough
Printed in Czechoslovakia

Contents

Introduction

Numbers in the margin
refer to illustrations

The Islamic world comprises a vast area stretching from Morocco to India and beyond, extending as far as the East Indies and reaching down into Africa below the Sahara. The present area of the Islamic world has contracted marginally from what it was in the Middle Ages, but basically it still embraces the same regions of Asia and Africa as it did at the height of the Ottoman Empire in the 16th century.

Many peoples and races inhabit this area, speaking languages which are quite distinct, and yet there is a fundamental unity about the Islamic world which is apparent to any visitor. It is a unity brought about by an allegiance to common religious ideals and, to a lesser extent, the sharing of a common history.

Islam is one of the three great Semitic religions, sharing with Christianity and Judaism a religious tradition stemming from the patriarch Abraham: a belief in the One God, creator of the universe; of humanity responsible to that creator for its actions; and in the certainty of the Final Judgement.

Islam was established in western Arabia by the Prophet Muhammad in the early 7th century, making it the most recent of the three 'revealed' religions. Nevertheless, the new faith claimed a historical mandate going back to the time of the creation; it saw itself as the original faith of mankind whose purpose had always been the communication of a divine plan for humanity and its implementation on earth. This divine plan was made known to Adam at the dawn of history, and then by successive prophets or messengers (among whom Islam numbered Abraham, Moses, Christ and finally Muhammad) to all the nations of the earth.

Muhammad differed from the earlier messengers, who had been only partially successful, in two important respects. For the first time mankind received the true revelation of the divine plan in the form of the Koran, which Muhammad believed to have been communicated to him by supernatural means; and with his acceptance by the inhabitants of Medina in 622 AD, an Islamic state was established to put the divine plan into practice. It is with this momentous event that the Islamic era commences.

Within a century of the Prophet's death in 632 AD, Muslim armies had extended the borders of the Islamic state to Spain in the west and Central Asia in the east. The head of the state was the caliph, temporal successor of Muhammad, whose function was to protect the domain of the believers and ensure that the divine law, the *Shari'ah*, was observed. The *Shari'ah* was based on the Koran and the actions and decisions of Muhammad which were assumed to have been divinely inspired. There was no division into secular and religious spheres and the law was all-embracing, codifying the minutest detail of the Muslim's daily life. It was observed by all members of the state except Christians and Jews, who on payment of a tax in lieu of military service lived a separate existence as protected communities.

Conversion to Islam was a simple matter; all that was necessary was to repeat the formula, 'There is no deity but God (Allah) and Muhammad is his Messenger.' But with these simple words the convert acknowledged the Islamic interpretation of history as an unending endeavour to establish an ideal society based on the divine plan, and in so doing he committed himself to a community of believers dedicated to the observance of that plan.

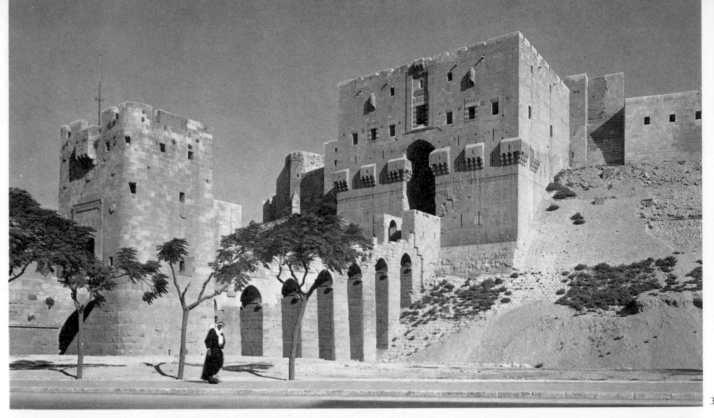

3

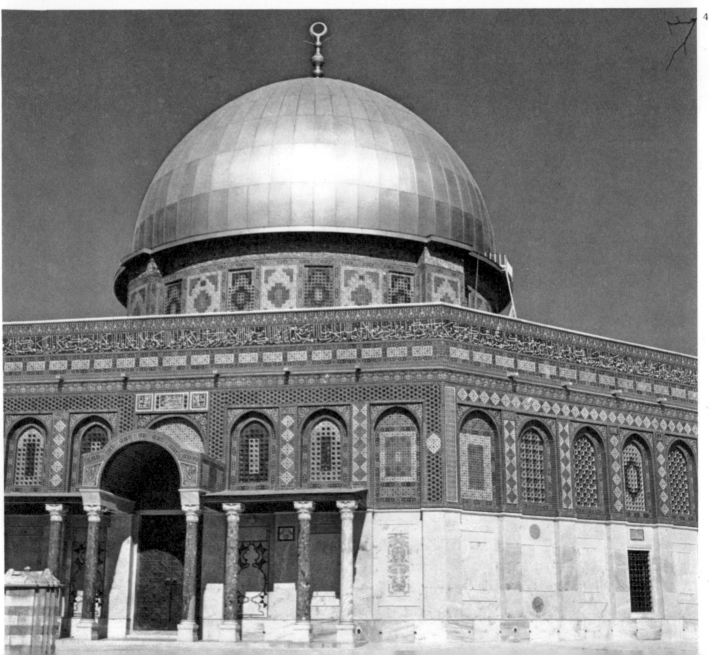

4

3 The Citadel, Aleppo, Syria, about 1210. Built by the Ayyubid Sultan Al-Zahir Ghazi (1186–1216), with later additions.

4 The Dome of the Rock, Jerusalem, 691. The most sacred building of Islam after the holy places of Mecca and Medina, erected over the spot from which the Prophet is believed to have ascended to Heaven. It is the oldest Islamic monument and one of the architectural masterpieces of the world. The high dome covers the Rock, the most important part of the shrine, and is surrounded by two concentric octagonal ambulatories for ceremonial processions. The interior is sumptuously decorated with marble, sheet metal and mosaics. The style of decoration is late Classical (i.e. Hellenistic), but

with a strong Sasanian element. The façade was originally marble and mosaic, but in the 16th century the building was restored by the Ottoman Sultan Sulayman and the external mosaic replaced with tile faience, including the magnificent Thuluth inscription which runs right round the upper part. Apart from the Ka'aba, the sacred shrine of Mecca, there is nothing quite like the Dome of the Rock elsewhere in Islam.

5 Ceramic vase, Damascus, Syria, 13th century. Height 12 in. Collection of the Marquis de Ganay, Paris. This vase bears the classic forms of Islamic decoration – calligraphy, foliate arabesques, geometric interlace – while the colours – blue and yellow-gold lustre – are perhaps the most important of the Islamic colour repertoire.

5

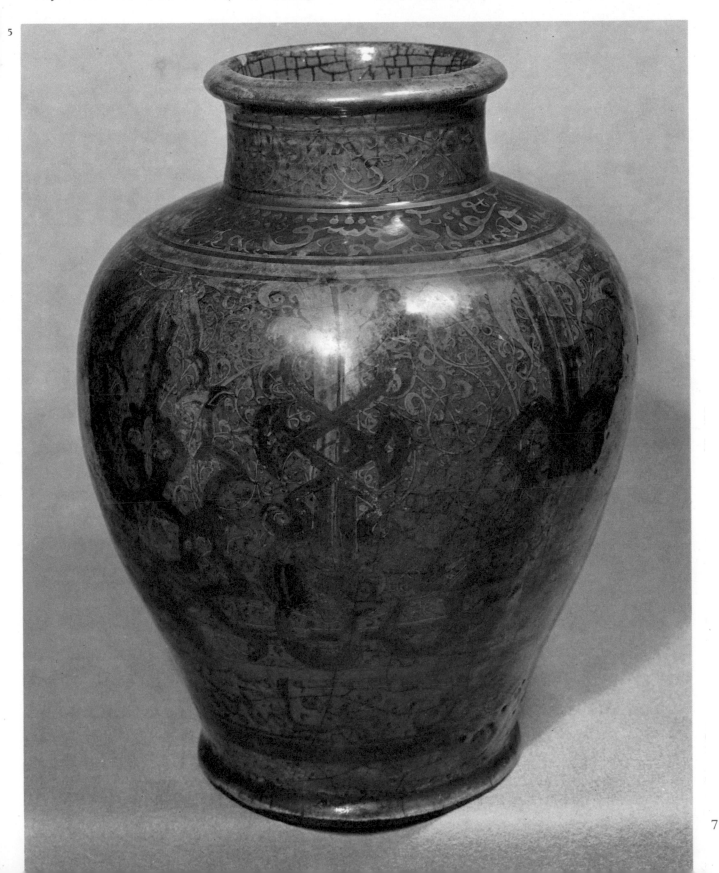

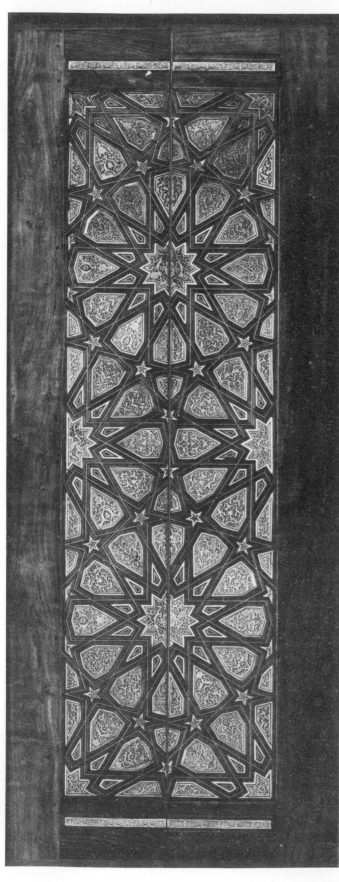

6 Pair of doors, Egypt, late 13th or early 14th century. Height 5 ft 5 in. Metropolitan Museum of Art, New York (Bequest of Edward C. Moore, 1891). The elaborate star-polygons in the centre of the doors were an important feature of Mamluke decoration and were used in metalwork, manuscript illumination and bookcovers, as well as woodwork. The irregularly shaped fillets in the spaces between the main design are of wood or ivory.

Thus to accept Islam was to live in accordance with the very structure of the universe.

The historical background

The Umayyad caliphate 661–750 The first four caliphs after the death of Muhammad were chosen from among his immediate followers and are called the Orthodox Caliphs. They controlled the expanding state from its first capital Medina (632–661). After the assassination of the last Orthodox Caliph, the Prophet's son-in-law Ali, the caliphate passed into the hands of the Umayyads, relatives of Muhammad, and the capital was removed to Damascus. In frank contradiction to the egalitarian principles of Islam, the Umayyads favoured the Arab subjects of the state and this led to their downfall.

The Abbasid caliphate 750–1258 In 750, largely due to Iranian assistance, the Umayyads were overthrown by the descendants of the Prophet's uncle, Abbas. The Abbasid caliphs built a new capital at Baghdad from where, in name at least, they ruled until 1258.

The establishment of the Abbasid caliphate signified the end of political unity. Beginning with Spain which remained in the hands of the Umayyads, the fragmentation of the huge state set in. The governors of outlying provinces had always enjoyed considerable freedom of action and they now became totally independent, though the spiritual authority of the caliph as Muhammad's successor was usually acknowledged. By 800, Spain (called Al-Andalus) and all North Africa were independent, and in 868 Egypt too was lost when its governor Ibn Tulun established a separate dynasty.

The Samanids 874–999 There was a similar disintegration in Iran and Central Asia. The most important of the early independent states in the east was that of the Samanids of Samarkand and Bukhara (874–999). The Samanids encouraged the revival of the Persian language and literature which had suffered in the short term by the prominence of Arabic. It was a vassal of the Samanids who encouraged Firdausi to begin his epic history of the Iranian nation, the *Shah-Nama*, in 957.

The Buyids 932–1055 Some local Iranian states

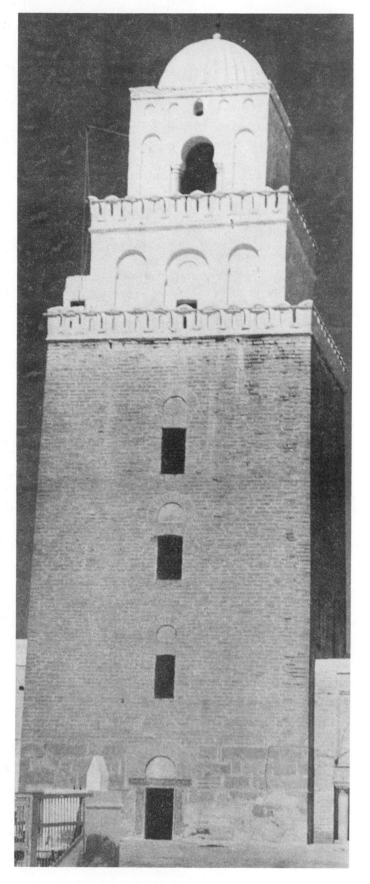

became powerful enough to occupy Baghdad and to intimidate the caliph. The Buyids for example, having established themselves in southern Iran, occupied Baghdad in 945 and turned the caliph into a mere puppet. The spiritual-secular unity of Islam had now disappeared at the highest level, for political necessity and ambition demanded that the two be separate, at government level at least. Although the Buyids favoured the Shi'ite cause, they paid lip-service to the caliph and allowed him to remain in office. The Shi'ites were the largest sect of Islam, believing that the caliphate was not an elective office but a hereditary one passed down from Ali, the last Orthodox Caliph, through his descendants.

The Fatimids 909–1171 The Fatimid rulers of Egypt and Syria were Shi'ites who did set up a rival caliphate which lasted until the dynasty was suppressed by Saladin.

The Umayyad caliphate of Cordoba In reply to the Fatimid threat, the Umayyad ruler of Spain, Abdal-Rahman III (912–961), proclaimed himself caliph in 927 and the Andalusian caliphate flourished until abolished in 1031. Thus for most of the 10th century there were three caliphs, one in Baghdad, another in Cairo, and a third in Cordoba.

The Seljuks and Ayyubids In the 11th and 12th centuries orthodoxy reasserted itself. The Seljuk Turks, a Central Asian people who established themselves in Iran (the Great Seljuks 1037–1157) and Anatolia (the Seljuks of Rum 1077–1300), destroyed the Buyids and occupied Baghdad in 1055, taking the Abbasid caliph under their 'protection'. Saladin put an end to the Fatimid caliphate, at the same time founding a dynasty, the Ayyubids, which controlled Egypt and Syria until the middle of the 13th century.

The invasion of the Mongols At the beginning of the 13th century the eastern part of the Islamic empire experienced the terrifying holocaust of the Mongol invasion, which turned northern and eastern Iran into a desert and, in 1258, extinguished the Abbasid caliphate when the city of Baghdad was sacked and the last caliph put to death.

Iran: the Ilkhanids 1256–1349 After the Mongol invasion the eastern part of the Islamic empire split up into several distinct areas. Iran continued

8 Carpet, north-west Iran, about 1700. 22 × 8 ft. Ex Collection Joseph V. McMullan, Fogg Art Museum, Cambridge, Massachusetts. For both religious and cultural reasons gardens, and the floral forms associated with them, provide a major theme of Islamic art. This carpet is one of a group which create in plan form the layout of an ideal garden, with trees, flowering shrubs and canals stocked with fish.

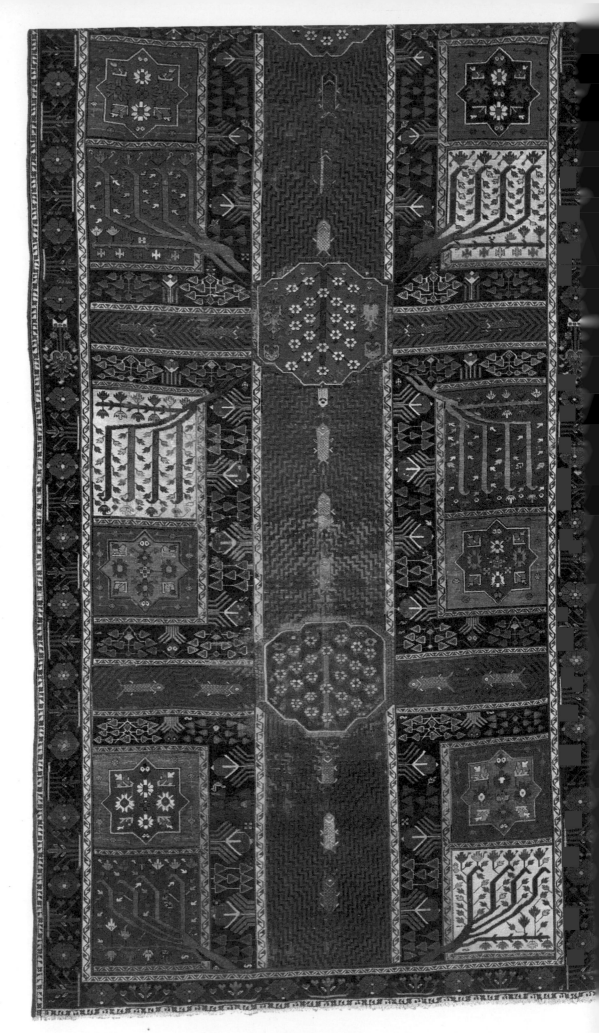

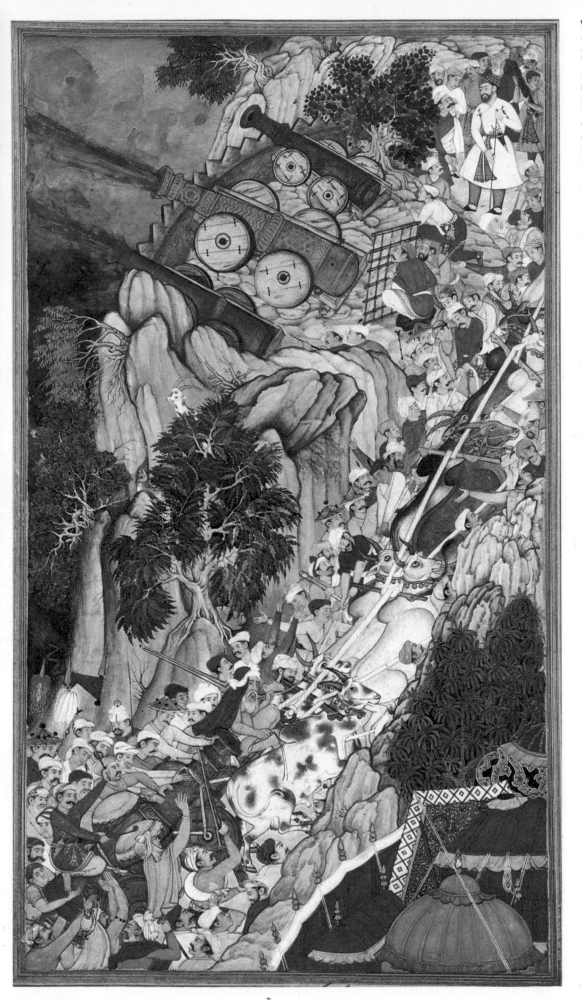

9 Scene from the *Akbar-Nama*, Mughal India, about 1600. 13 × 8¼ in. Victoria and Albert Museum, London. The scene illustrates an incident during one of the Emperor Akbar's campaigns: bullocks dragging siege guns for an attack on the Fort at Ranthambhor. Although the artists intended this picture to celebrate the personal power of Akbar (the eye is conveyed straight towards him at the top of the struggling column, aloof and slightly larger than his neighbours), nevertheless the porters and soldiers are rendered with great individualism and realism. This realism extends even to the trees which are now recognisable botanic specimens. Mughal painters and draughtsmen tended to specialise, and often several collaborated to produce a single painting. This picture was drawn by Miskin and painted by Paras.

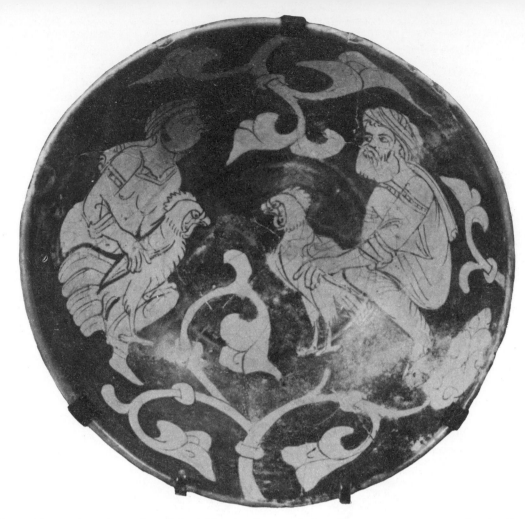

to be ruled by a Mongol regime, the Ilkhanids, until 1349 when the country was divided up among a number of prominent chiefs and local governors. In 1384–1393 Iran was once again subject to an invasion from Central Asia, this time by a Turkic people under Timur (Tamerlane), whose descendants controlled Iran for more than a hundred years.

The Timurids and Turkomans 1378–1502 The Timurids were perhaps the greatest patrons of Persian culture, and during their rule the arts, particularly painting, reached one of its highpoints of development. It was a classic case of the victors conquered by the civilisation of the subject people.

The Timurid domains in the west of Iran were slowly eroded by the Aq-Quyunlu, or White Sheep Turkomans, Turkish-speaking nomads from the area around Lake Van. After some thirty years of sole authority in western and central Iran, the Turkomans were defeated by the Safavids.

The Safavids 1501–1736 The Safavids were a native Iranian Shi'ite dynasty which by 1502 controlled all of Iran from east to west. They were among the most successful rulers of Iran and under them the country enjoyed more than two centuries of uninterrupted prosperity. The greatest period of Safavid rule was the reign of Shah Abbas (1587–

1629), when Iran recaptured a brilliance unknown since Antiquity.

Turkey: the Ottomans 1299–1922 Implacable enemies of the Safavids were the Ottoman Turks, leaders of orthodox Islam. The Ottomans were one of the many Turkoman tribes which superseded the Seljuks of Anatolia but became strong enough to extend their power over the whole of Asia Minor and to destroy the remains of the Byzantine Empire, capturing Constantinople in 1453.

In the 16th century the Ottomans initiated a new period of conquest similar, in the vast area of territory captured, to that of the first century of the Islamic era, although not accompanied by the massive conversions of the early period. In 1529 Sultan Sulayman the Magnificent besieged Vienna, and in 1540 an Ottoman fleet attacked Gibraltar. The Ottoman armies were equally active within the Islamic world; they defeated the Shah of Iran at the Battle of Chaldiran in 1514, and three years later occupied the Mamluke sultanate of Egypt and Syria.

Egypt and Syria: the Mamlukes 1252–1517 The Mamlukes had controlled Egypt and Syria since the middle of the 13th century. They were originally Turkish and Circassian slaves who served in the Ayyubid army, but who seized power for

10 Ceramic dish, Egypt, 11th–12th century. Collection of Edmund de Unger, London. The pottery of Fatimid Egypt has some of the earliest and finest examples of the new naturalistic tendency which became increasingly prominent during the 12th century. The scenes on Fatimid lustre-painted pottery often look as if they have been based on events and incidents actually witnessed in the street or marketplace–like this cock fight.

11 An encyclopedia of warfare, Cairo, 1366. 13 × 9¾ in. Chester Beatty Library, Dublin. As a military caste the Mamlukes were avid readers of works on tactics and warfare, and this encyclopedia was perhaps the most popular of the later Middle Ages. This scene shows a knight exercising with two swords and shields. Mamluke painting is far more formal than that of 13th-century Baghdad; there is a strong tendency to draw figures, singly and in groups, in poses that are rigidly symmetrical.

وسط الموكب ثم سل يدك اليمنى بالدرقه

ورق بهاى فى وجه الموكب ثم اعقد بها عقده مليحه واعدها
الى مثلك الايمن وعينك الى الموكب ودرع حالك حتى تنتهى الى
المعبره فاضرب بيدك اليمنى على قايم السيف الذى كان فى
يدك فجرزه من موضع الجها رعقده من فوق راسك انبوضه ورد
راس فرسك شمالا وغطى وجهك بالدرقه وانظر من تحتها الى
الموكب فتتقى السيف معارضا نحو مينك وذبابة السيف

و قال يا محمد ربّك يقرؤك السلام ويخصك بالتحية والاكرام
حق تعالی سڭا سلام قلدی ايندی اشته جبرائیلی

سڭا كوندردم ده مكه سنوك امروكه مطيع اولاسنوك
دوشمنلرول هلاك ايله ايله بننكم كوك كاول ديبلر

14

12 Scene from the *Siyar-i Nabi* (Life of the Prophet), Constantinople, 1594. 7¾ × 7½ in. Spencer Collection, Public Library, New York. One of a huge series of paintings in a work of several volumes. These pictures have an austere, fundamentalist religious quality, although they are without any devotional purpose. But the presentation of the Prophet, clad entirely in white with veiled face and flame halo, is calculated to surround his person with an air of sacred mystery. The text is written in majestic Naskh, which on the illustrated pages is floated on a gold background.

13 Scene from the *Maqamat* (Assemblies) of Al-Hariri, Baghdad, Iraq, 1237. 10 × 10½ in. Bibliothèque Nationale, Paris. The paintings in this manuscript, and others from Baghdad in the early 13th century, represent the culmination of the realist tendency in 12th- and 13th-century art. This scene shows a pilgrim caravan on its way to Mecca. The script is Naskh.

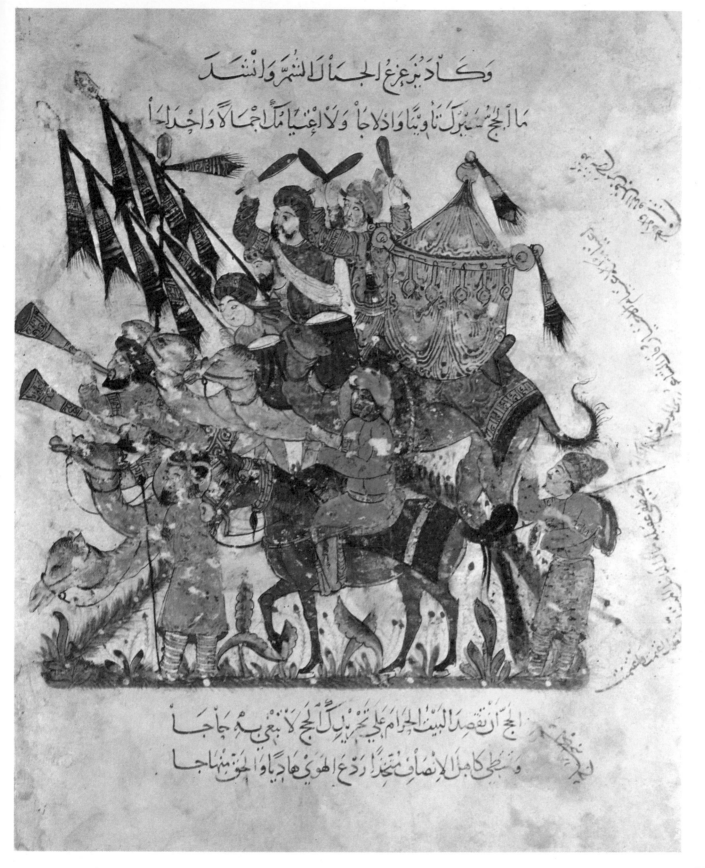

themselves. The greatest achievements of the Mamlukes were the final extinction of the Crusader states in 1291, and the stemming of the Mongol advance at the Battle of Ayn Jalut in Palestine in 1260. The Mamlukes owed allegiance to the Abbasid caliph, and after the sack of Baghdad in 1258 set up a relative of the last caliph in Cairo. His descendants continued in office until 1517 when the reigning caliph was taken to Constantinople by the Ottomans, where the sultan assumed the title.

Islamic Spain 1031–1492 After the abolition of the Umayyad caliphate of Al-Andalus in 1031, Muslim Spain fragmented into many little kingdoms and statelets. As such they were easy prey for the Christian states in the north of the peninsula, and undoubtedly had it not been for the invasion of Spain by two warlike Berber dynasties, the Almoravides in 1090 and the Almohades in 1145, the reconquest would have been completed in the 11th century. After the decline of the Almohades a number of petty states sprang up, but the only important one was that of the Nasrids of Granada (1232–1492), which survived until the conquest of Granada by Ferdinand and Isabella in 1492.

India The conquest of north-west India was achieved not by the early Muslim armies but by the Ghaznavids, a Turkish dynasty which had established itself in Afghanistan after being governors of the Samanids. The Ghaznavids (962–1186) were succeeded by the Ghorids (1148–1215), who, having conquered northern India to the mouth of the Ganges, appointed a Turkish slave, Qutb al-Din Aybak, to act as viceroy at Delhi. Qutb al-Din founded a dynasty, the first Muslim dynasty to reign exclusively in India, which governed Delhi for eighty years. These rulers are known as the Slave Kings (1206–1287). The Delhi sultanate continued in Turkish hands under the Khaljids (1290–1320) and the Tughlakids (1320–1412), until the invasion of Timur in 1399. The sultanate was then controlled by the Sayyids (1414–1443) and the Lodis (1451–1519), though these were only two of many Muslim states in northern India.

In 1526 Babur, a descendant of Timur, arrived in India claiming the country as his right. He established the Mughal Empire, although initially this was short-lived, as his son Humayun was forced to flee India to seek refuge at the Safavid court at

Tabriz (1540–1555). However he was able to return and the task of consolidating the Empire fell to his son Akbar (1556–1605), perhaps the greatest monarch of the 16th century.

The art of Islam

Like all the great civilisations of the world, Islam possesses a strong architectural and iconographic tradition. But while the former has been known to Europe ever since the first visitors to Spain and the Middle East admired and grudgingly acknowledged the architectural splendours of Cordoba and Jerusalem, the latter was hardly known to exist. Being for the most part contained in illustrated manuscripts locked away in libraries, it is only in the present century that scholars have been able to evaluate the pictorial tradition of the Islamic world.

But Islam has two other artistic traditions, calligraphy and non-representational art, at least as important as architecture and far more universally used than representational art.

Calligraphy is the highest art form of the Islamic civilisation; no appreciation of Islamic art is possible without understanding the importance and significance of its calligraphic tradition. Non-representational art in the form of the floral or geometric arabesque was even more widely applied than calligraphy, being used to decorate every conceivable surface from the smallest casket, piece of pottery or metalwork, to the wall of the largest mosque.

Calligraphy, the arabesque, and to a lesser extent representational imagery were employed right across the Islamic world, in all periods from the very earliest, and in every conceivable media.

But within the boundaries of Islamic civilisation, there arose a host of smaller local cultures—Islamic Spain, Mughal India, the Mamlukes, Ottomans etc.—all owing a basic allegiance to a common ideal yet each in some way distinct from its neighbours and predecessors. Thus the artistic traditions of Islam, while at first presenting an aspect of monolithic uniformity, often prove on examination to be imbued with the particular character of a local civilisation and as such quite different and independent.

[For the purposes of this book the word Iran is used to describe the country, while the term Persian is used to describe the art.]

propagandist purpose. The vigorous portrayal disguises the fact that the theme of the triumphant lion in Near Eastern art goes back to Antiquity.

15 The Alhambra, Granada, Spain, 14th century. The most perfect example of western Islamic architecture. The Court of Lions shown here is the centre of the harem, or private apartments of the palace. In the middle of the court is a fountain with twelve symbolic lions, a rare example of Islamic free-standing sculpture, and from this four channels carry water into the surrounding halls. The interior of the palace has a delicate, weightless character which contrasts strongly with the stark appearance of the exterior.

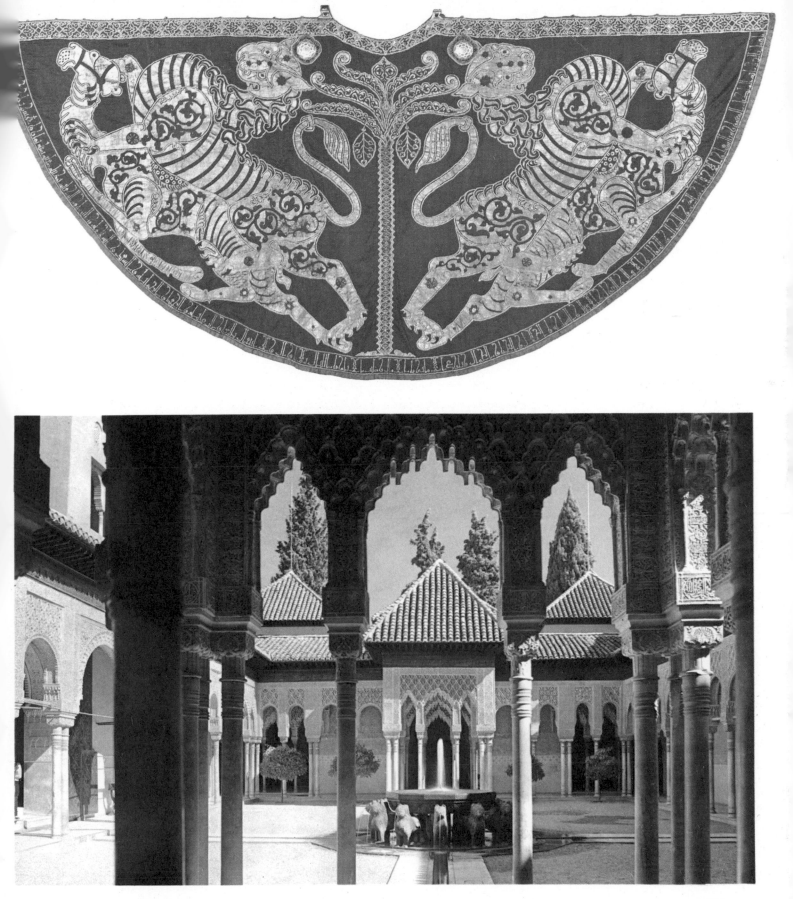

Calligraphy

Although at times in Europe the art of beautiful writing has enjoyed the favour and patronage of both Church and State – Roman monumental inscriptions and the pages of the Book of Kells for example – by and large calligraphy has been an ancillary, if intimate, art form, inevitably associated with libraries, books and scholars. In Islam on the other hand, as even a casual glance through this book will illustrate, the importance of fine writing is overwhelming, as an art form *per se* and as a means of multi-media decoration, for the application of calligraphy has never been restricted. Just as the early disciples of the Prophet inscribed his revelations on anything that came to hand – the shoulder-bone of an animal, a piece of palm leaf – so in subsequent periods when architectural decoration and various craft industries developed, there was no feeling that calligraphy was only properly executed on vellum or paper. Indeed it is arguable that Islamic calligraphy achieved its highest expression not on paper at all, nor even in architectural inscriptions, but on the humble pot.

The suitability of the Perso-Arabic script to occupy its position at the very centre of the visual arts of Islam, the pivot around which all others revolve, is explained and justified by its high level of aesthetic attainment. Nevertheless, this achievement is only understandable as a consequence of the role accorded to the Arabic script by virtue of its association with the Koran. It is the association of script and scripture in the mind of every Muslim that accounts for the rapid development of the script, from graffiti to the first classic form within a century of the Prophet's death; and it is this association that we must grasp if we are to understand the dominance of calligraphy in the visual arts of Islam.

The Koran, we have seen, is the collected revelations of Muhammad in written form. However the entire *raison d'être* of the Prophet's mission was that these revelations were of divine origin – literally; in other words that the Divinity communicated His plan for mankind through the agency of Muhammad on certain occasions between the years AD 600 and 632. Now this meant that the written revelations were of a very special nature; for as the universal divine plan was set forth in the words of the Creator, thus it took on some of His attributes. Consequently the Koran is not comparable with the New Testament (simply the record of Christ's earthly mission) but rather with the person of Christ Himself.

When, shortly after the Prophet's death, the revelations were assembled and put into their final written form it must have been apparent that these revelations should be presented in a way worthy of their momentous significance. And so from the first years of Islam arose the idea of presenting the Koran using the finest form of handwriting allowed by the primitive script. In this way religious emotion and aesthetic sensibility were inseparably fused, and from this powerful combination a wave of creative energy welled forth.

The Kufic script

The initial, and always most important, task of the calligrapher was the production of copies of the Koran for both personal and communal use. The latter were employed in the mosque for which they were either officially commissioned or donated by pious bequest. They were regularly of large format, perhaps several feet across when open, and written

16 Ceramic bowl, Samarkand or Nishapur, 9th–10th century. Brooklyn Museum, New York. This bowl is one of a group produced in Samanid times. The decoration on these bowls and plates is considered the finest adaption of the Arabic script to pottery. On many pieces the vertical strokes converge towards a central dot though on a few they radiate outwards towards the rim. Some of the double horizontal strokes are plaited, the first signs of the transformation of the script into a purely abstract form of art.

in a special form of Arabic script. This earliest version of the script was called Kufic after the city of Kufa in Iraq, where it was said to have been invented. Like all subsequent developments of the primitive 7th-century script, Kufic existed in numerous variants. However only one of these was used for the Koran. This is based on the circle, short vertical, and elongated horizontal, often doubled so that it hugs the line on which the text rests, conforming thereby to the horizontal format of the 7th- to 10th-century koran. Koranic Kufic of this period has a bluff, austere quality which is quite easy to recognise.

Kufic was not entirely confined to the sacred scripture, for its use was extended to coinage (quite appropriate given the single character of the state), official documents, and to some extent architectural inscriptions. For the embellishment of a building however, and for carved inscriptions in general, forms of Kufic were employed in which the expressive, we might even say personal, potential of the letters was more readily released.

From earliest times inscriptions were included in the design of religious architecture, particularly in the case of mosques where quotations from the Koran served a purpose similar to the devotional imagery of the Christian church. The earliest surviving Islamic monument, the Dome of the Rock, contains an inscription in simple Kufic running around the interior octagonal arcade. As this simple form lent itself very well to execution in mosaic and tile brick, later examples in those media–the mihrab of the Great Mosque of Cordoba (965) or the drum of the Gur-i Amir in Samarkand (1405)–preserve the basic form of the letters barely embellished. However neither of the later inscriptions is entirely free from the influence of the more decorative forms of Kufic.

Throughout the Middle Ages foliated and floriated Kufic were used in both religious and secular architecture, particularly when stucco or carved stone was employed. Although the two forms may appear at first sight to be identical, in reality there exists an essential difference between them. In foliated Kufic the verticals end in half-palmettes, and often the final letters of words are exaggerated vertically and culminate in leaves or half-palmettes. This latter device was very useful to the artist-calligrapher in enabling him to maintain the repetitive, rhythmic procession of vertical strokes which

the literal form of the letters may not have supplied. Foliated Kufic was sometimes set against a curling pattern of leaves and tendrils and in this event its resemblance to its elaborate related form, floriated Kufic, is even more pronounced. The floriated form, however, is readily distinguishable by the fact that, in addition to the characteristics mentioned in connection with foliated Kufic, leaves and palmettes actually grow from the body of the letters themselves.

Whenever floriated Kufic was used to write Koranic quotations on a mosque interior, its apparent indecipherability did not present the kind of problem which we might suppose: Koranic inscriptions were not there to be read but to create a divine presence; and had it ever been necessary to interpret them no difficulty would have arisen, as learning the Koran by heart was the cornerstone of Islamic education.

Floriated Kufic seems to have been invented towards the end of the 8th century, probably in Egypt where similar decoration has been noted in pre-Islamic Coptic writings.

Early calligraphy in Iran

It was not solely in Egypt that special forms of Kufic were cultivated, for both Iran and the Maghreb devised variant forms of the script. The Arabic script

17 Bronze bucket or kettle, Herat, Iran, dated 1163. Height 17½ in. The Hermitage, Leningrad. The bronze surface is richly inlaid with figurative imagery in gold, silver and copper. The importance of representational art in this period is indicated by its intrusion into the calligraphy in the upper and lower registers. Although the themes of the figure decoration are entirely courtly, the bucket was made for a merchant. The wealthy urban bourgeoisie seem to have played a major part in the 12th- and 13th-century 'renaissance' of figurative art.

18 Koran, 9th–10th century, 13 × 9¾ in. Chester Beatty Library, Dublin. Early Kufic script. The vowels are indicated in red and the diacritical points by short black strokes. 'Purist'

17

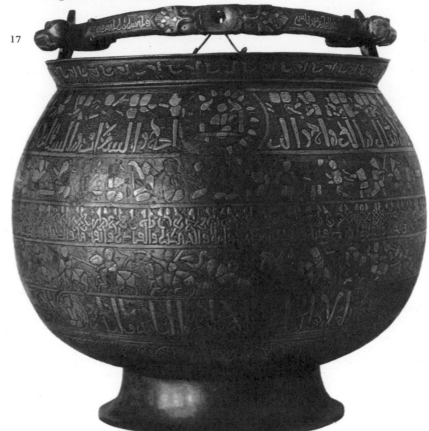

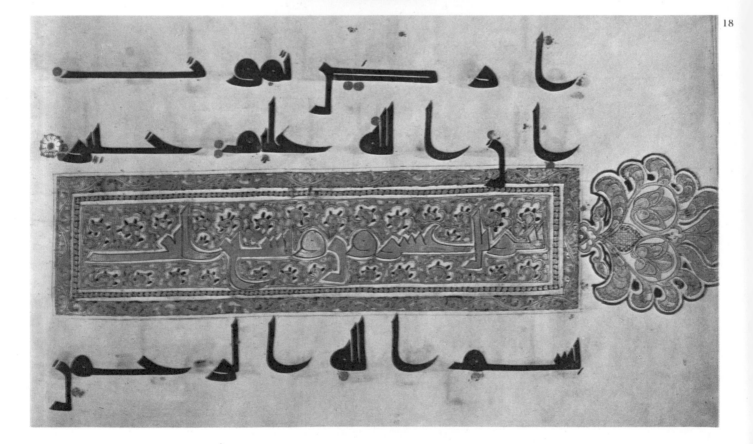

18

calligraphers often preferred to leave these out and present the text in its primitive form. This gave the script a majestic simplicity, though this could result in inaccurate readings, particularly if the reader was a non-Arab. In the centre is the illuminated 'heading of Sura [chapter] 32'. At first the Koran was undecorated but gradually, probably due to the influence of Christian illuminated manuscripts, embellishment was added culminating in the magnificent double frontispiece.

19 Gold pitcher from Iraq or Iran, 10th century. Height with handle 6 in. One of the few objects in precious metal to have survived from early Islamic times. It was made for one of the Buyid rulers of Iraq, whose name is given in the Kufic inscription on the rim. The surface is decorated with fabulous animals, some of ancient origin. In the early period of Islamic art representational imagery is generally associated with royal objects.

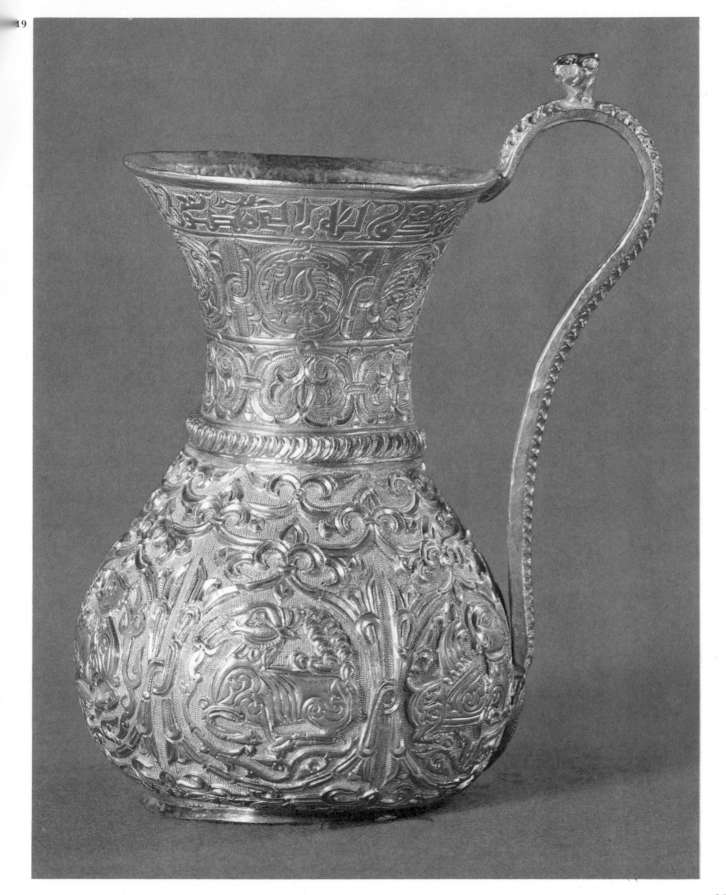

had been adopted in Iran quite soon after the Islamic conquest of AD 642, largely because it was the official script of the new state into which Iran was incorporated, though also because it was obviously superior to the older script in which the Persian language had been written hitherto. The appeal of the Arabic script was as great for the Iranians as it was for the Arabs, perhaps even more so; for although the Arabs had used their script before the coming of Islam, to Iranians the script was directly associated with the miracle of the Koran and therefore linked with their own religious feelings.

Although Naskh replaced Kufic as the normal koranic hand throughout most of the Arabic-speaking area of Islam in the 10th century, Iran saw the use of peculiarly local forms of the old script continued for several centuries more. We find Eastern and Qarmathian Kufic, as these forms are called, employed for the writing of korans down to the 13th century, though we have no idea when or where they originated. Calligraphy in Iran as in the rest of the Islamic world was truly international in the sense that, despite its importance and the numerous biographies of calligraphers, the art was practised so widely that we have very little real evidence to be able to ascribe the various hands with their multiple variations to particular calligraphers.

One of the most striking examples of the ability of Persian calligraphers appears on the white slipware of 9th- and 10th-century Samarkand and Nishapur. This pottery is associated with the Iranian Samanid dynasty, noted for its involvement in the contemporary renaissance of Persian literature. Aesthetically the combination of a smooth ivory-coloured surface and a simple Kufic inscription, painted in black and running around the perimeter of the bowl or plate, is extremely satisfying. Although the inscriptions of the later examples become too ornate

and are sometimes suffocated by the addition of foliate motifs, the early bowls have a mood truly reflected in Arthur Lane's description of them: 'Their beauty is of the highest intellectual order; they hold the essence of Islam undiluted.' This is made even clearer when one realises that the Arabic inscriptions are not Koranic, which was not permitted for fear of profaning the sacred text, and that the bias of the ruling dynasty was definitely anti-Arabic and pro-Persian. Thus the unique beauty of the Samanid plates can only be explained by reference to a deeply felt attachment to the script itself, as that of the language in which the Koran was revealed. This would have been perfectly normal, even under the Samanids who were by no means anti-Islamic. Kufic inscriptions had been included in the decorative schemes of pottery, metalwork and textiles prior to its use on Samarkand slip-painted ware, but it was in the Samarkand pottery that calligraphy was employed as the central element for the first time.

Cursive script: Naskh

In even the earliest Kufic korans a tendency to introduce cursive forms can be noticed. In fact a purely cursive script had existed almost from the first, being employed for ordinary correspondence. The cursive script called Naskh had many advantages over Kufic; it could be written more rapidly, and because diacritical points and vowel sounds were normally indicated it was readily intelligible. One of the major disadvantages of simple Kufic was its lack of orthographic signs, essential to distinguish the twenty-eight sounds of the sixteen basic characters of the alphabet. The differentiation of the various sounds was usually accomplished by the addition of one, two, or three dots above or below the letter. Although the full range of orthographic signs existed by the mid 8th century, they were often disregarded by conservative koran scribes who, no doubt, regarded them as an unnecessary modern innovation.

Two famous calligraphers were associated with the development of the Naskh script. That one of these was a high government official and the other a house-painter further emphasises the universal appeal of calligraphy as an art form in the Islamic world. The first of these was Ibn Muqla (died 939), a minister of the Abbasid caliph of Baghdad, and so skilled an artist was he that when his hand was cut

off after his fall from grace he was able to attach a pen to his stump and write as well as before. Ibn Muqla's contribution to the art of calligraphy was not the invention of a new script but the application of systematic rules to the informal Naskh hand. This he did by bringing every letter into relation with the *alif*, the tall vertical which gives the Arabic script its regular sonorous rhythm.

This 'proportioned script' of Ibn Muqla was brought to perfection by Ibn Al-Bawwab (died 1022), a house-decorator who turned his hand to calligraphy. At some time in the 10th century Naskh was used for writing the Koran. However the earliest existing koran in Naskh script is the well-known copy in the Chester Beatty Library, Dublin, which has been positively ascribed to Ibn Al-Bawwab. It is a work of almost faultless perfection: Ibn Muqla's basic notation orchestrated by an artist of genius.

By this time, that is the 11th century, six basic styles of writing were in common use. These were referred to as the Aqlam al-Sitta (the six hands) and given technical terms: Naskh, Thuluth, Rihan,

Muhaqqaq, Tauqi', Riqa'. These styles arose in the Arabic-speaking part of the Islamic world, and to them we must add two more which were invented in Iran: Ta'liq and Nasta'liq. In eastern Islam all of the six basic scripts, in addition to the various Kufic forms, were in use from the 11th century onwards. The two later forms, Ta'liq and Nasta'liq, did not appear until the 14th, but by the 15th and 16th centuries the latter was the predominant style of calligraphy in Iran.

What makes the Arabic script so successful from the artist or decorator's point of view is its fully developed dimensions. This is not simply because the vertical 'warp' and horizontal 'weft' establish an automatic equilibrium, but more important because the vertical or horizontal emphasis can be radically altered without disturbing the balance or rhythm. If we want to understand the difference between the various types of script, at first so confusing, we can perhaps see Naskh as a style in which the weight is evenly distributed, the remainder of the six hands as vertically orientated, with the final two decidedly horizontal in emphasis.

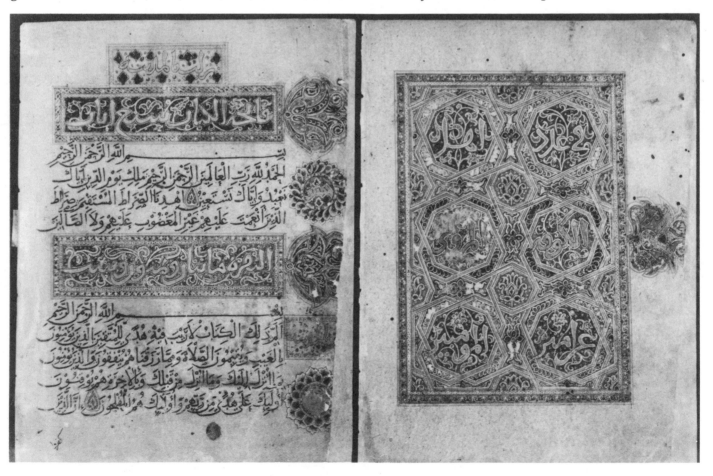

22 Koran, Iran, 11th–12th century. 13¼ × 9½ in. Chester Beatty Library, Dublin. So-called Qarmathian Kufic. This type of script is usually associated with the Seljuks of Iran and is almost invariably written over a composite foliate background. The diacritical points appear as black dots and the vowels are indicated in red. These orthographic signs are similar to those used today. This example illustrates one of the most important advantages of the Arabic script: letters can be extended vertically or horizontally without the overall balance being impaired.

23 Frontispiece from a Mamluke copy of the *Kawakib Al-Durriyyah* (a poem in praise of the Prophet), Cairo, 15th century. 16 × 11¾ in. Chester Beatty Library, Dublin. This is a calligraphic-abstract equivalent of a pictorial power theme; the entire page consists of the Sultan's name (Qayt Bay, 1468–1495) and titles in majestic Thuluth. The colours, predominantly red and gold, are those generally associated in the East with royalty. The name and titles are used as heraldic symbols, and the latter were partly chosen for the imposing visual effect they created when written. White symbolises purity but here has a particularly Mamluke reference, for white was the official colour of court dress in the summer months.

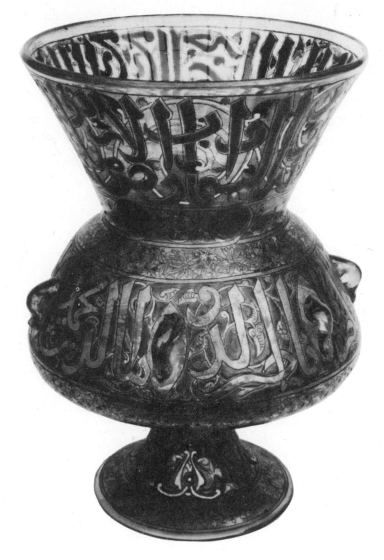

24 Mosque lamp, Syria, 14th century. Height 14 in. National Museum of Ireland, Dublin. Many hundreds of similar lamps were produced in Mamluke times, usually with the Light verse from the Koran on the neck and the name of the sultan, or person who commissioned it, on the body. This lamp bears the name of Sultan Muhammad (died 1340) in gold Thuluth and the Light verse in blue.

Calligraphy after the 13th-century Mongol invasion of the Near East

After the disastrous events of the 13th century (the Mongol invasion and the collapse of the Abbasid caliphate), the Islamic world split up into quite separate and definable areas: Turkey, Iran, Central Asia and the Mamluke sultanate of Egypt and Syria. To these regions we can add Islamic Spain and the Maghreb, which since the mid 8th century had been rather isolated from the rest of the Islamic world. We can identify particular scripts with certain of these areas—not necessarily that one form or the other was employed solely in a particular region, but that some forms achieved their highest expression in specific geographical areas, to the extent that several scripts have become permanently identified with definite areas of eastern and western Islam.

The Mamluke rulers of Egypt and Syria were a closed warrior-caste of Turko-Mongol (the Bahris) and Circassian origin (the Burjis), who had been introduced as slave-soldiers by their predecessors the Ayyubids. Although the Mamlukes were by any standards bloodthirsty tyrants they extended an impressive patronage to the arts, particularly architecture, building a great many mosques and madrasahs (religious colleges) which they equipped with korans, lamps and all the necessary furniture. Many of the korans written for the new mosques are of enormous size, so large in fact that it requires two men to lift them. Nevertheless, contrary to what one might suppose, these are by no means vulgar displays of dubious ostentation. The rigid military society of Mamluke Egypt showed an understandable preference for hierarchic Thuluth, the most dignified form of the Arabic script. This was employed for almost all official calligraphy, whether religious or ceremonial. Korans were written in varieties of majestic Thuluth and so in addition were many of the books destined for the library of the sultan. These were often religious works themselves, such as the *Kawakib Al-Durriyyah*, a 23 celebrated panegyric on the Prophet Muhammad. These books often commenced with an elaborate frontispiece in which the name of the ruler and his titles were prominently displayed, sumptuously inscribed in gold or white on a red or blue ground. Often the sultan's name and titles became a heraldic symbol in itself which was repeated in the same way whenever it was required to be used. These titles were partly chosen because of the imposing effect they created when written: the tightly disciplined parade of multiple vertical strokes immediately brings to mind massed ranks and state processions, particularly when done in white, the official colour of court dress throughout the summer months.

The Mamluke artists and craftsmen brought calligraphy on glass and metalwork to a level of perfection never to be surpassed. 12th- and 13th-century inlaid metalwork from Seljuk Iran, Syria and Mesopotamia was dominated by figure decoration; in Mamluke times the human figure disappears and a new emphasis is given to calligraphic inscriptions. Much of this metalwork was for the royal household and thus the inscriptions are somewhat grandiose.

In Antiquity the craftsmen of Egypt and Syria had mastered the technique of glassmaking. Under the Mamlukes this art was brought to perfection and

a variety of fine bottles, flasks and beakers was produced. Unquestionably the noblest pieces of Mamluke glass are the lamps destined to hang in the new mosques built by the sultans. These lamps, which look so unstable when seen in museums, were of course meant to be viewed from below with the light inside illuminating the coloured enamel inscription. Many lamps bear on their neck part of the mystical Koranic verse from the Chapter of Light (ch. 24 v. 35), in which God is compared to a lamp whose light illumines the universe, while the body bears the titles of the reigning sultan. This curious combination of spiritual and mundane calligraphy could be taken as an example of the fusion of religious and secular spheres in Islam, though it is probably more realistic to see it as simple evidence of the way in which the Mamluke ruling institution was able to intimidate the religious one.

Iran: the development of new forms

In Seljuk Iran Naskh was in habitual use by the 13th century for ordinary correspondence and the production of literary works. When Iran began to recover from the Mongol devastation of the 13th century and Timur's (Tamerlane) invasion of the 14th, we see specifically Persian forms of writing emerging: Ta'liq and its derivative Nasta'liq.

Ta'liq ('hanging' script) seems to have been formalised in the 13th century, though it had been in existence for several centuries prior to this and was in fact claimed to be derived from the old script of pre-Islamic Sasanian Iran. Ta'liq was written with a thick pen obliquely cut and looks quite different from the earlier scripts. Basically it is the combination of short thin verticals with broad horizontals

27

26 Frontispiece from a Mamluke copy of the *Maqamat* (Assemblies) of Al-Hariri. Egypt, 1334. $7\frac{1}{2} \times 6\frac{3}{4}$ in. National Library, Vienna. An excellent example of a power theme with the Muslim painter reverting to the natural propagandist role of the Oriental artist. This formal image of an enthroned ruler, with its gold background, symbolic genii and heavy frame is in complete contrast to the humorous, relaxed atmosphere of the Baghdad *Maqamat* illustrations, and is entirely appropriate to the rigid military caste for which it was painted.

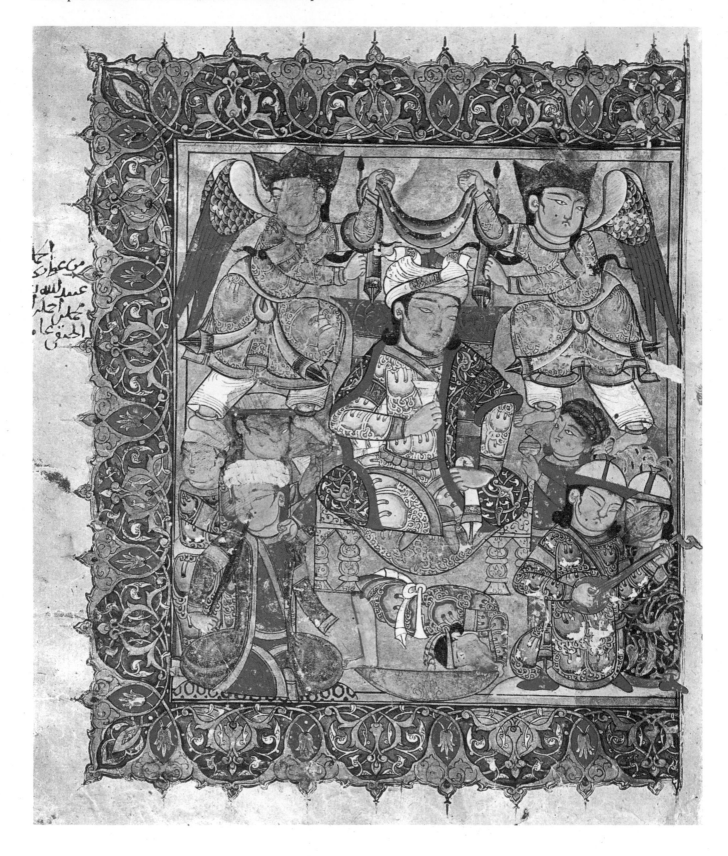

27 Painted ceiling of the Palatine Chapel, Palermo, about 1140. Executed for the Norman king of Sicily, the ceiling represents the most important work of Fatimid artists. The paintings consist of symbolic courtly and power themes, many of which can be traced back to the art of pre-Islamic Iran. A number of sections depict subjects from everyday life, which came into the repertoire of the court artists from contemporary painting on pottery where such scenes were increasing in popularity. The ceiling has been repainted in parts by European artists.

28 *Hilyah* (Description of the Prophet), Turkey, 1691–1692. 18½ × 13½ in. Chester Beatty Library, Dublin. The physical description of the Prophet according to his son-in-law Ali is contained in the central circle, and written in Naskh script. At the top is the *Basmallah* in Thuluth. The names of the four Orthodox Caliphs are written in cloud shapes around the circle. This is the *Hilyah* in its simplest form; often other designs and symbolic devices were added. The script is by the great Ottoman calligrapher Hafiz Osman (1642–1698), who is credited with the invention of the *Hilyah*.

accomplished calligraphy reproduced in glazed tiles on the walls of buildings in the city.

Calligraphers were an essential requirement for any self-respecting court, both to instruct the prince's children in the principles of the art and, most important, to produce manuscripts for the royal library. A case in point was the famous Ja'far of Tabriz who became the court librarian of the bibliophile Prince Baysunqur of Herat (1397–1433). Ja'far was conversant with all the calligraphic styles then current, but was particularly noted for his command of Nasta'liq at which he was only surpassed by its inventor Mir Ali of Tabriz who, according to tradition, had been inspired to devise the new script at the behest of a partridge which appeared to him in a dream and instructed him to shape letters like the wing of a bird.

Nasta'liq is a lighter, at times almost ethereal, version of Ta'liq, which due to the tendency of the script to rise up at the beginning of a word, and the emphasising of the slightly disembodied diacritical dots, seems to float in midair, an effect which was increased by the device of writing verses inside cloud shapes. Nasta'liq became the national calligraphic style of Iran, 'the expression of a highly civilised, sophisticated people' (A.U. Pope).

Just as in 17th-century Iran highly personal forms of drawing and painting arose, so the final calligraphic development in Iran was a personalised Nasta'liq called Shikastah or broken script. Shikas- **25** tah is really an elaborate, romantic form of handwriting in which, contrary to its implied meaning, the natural pauses between the letters and words are blurred by the writer joining up the normally empty passages of the verse or sentence. A length of Shikastah often brings to mind a sash or turban drawn in the 17th-century Riza-i Abbasi style with **49** multiple folds and 'sputtered' endings. In fact, as we shall see (page 52), in that century calligraphy **53** and painting were more intimately related than at any other time.

Under the Timurids, and especially the Safavids, the application of calligraphy to architectural surfaces reached new heights. From the earliest times tiles had been used in mosque decoration, and even in the first half of the 14th century we find Persian mosques with whole areas covered in polychrome tile faience. Under the Timurids and Safavids the entire surface of the mosque was covered with coloured tiles bearing decoration and magnificent

whose natural length is exaggerated wherever possible, especially at the ends of words. Only rarely was Ta'liq–and Nasta'liq too–used to write Arabic; normally it was reserved for Persian. Aesthetically this was a sound choice, for in Arabic it was the definite article, indicated by two parallel verticals, whose recurring beat lent the script much of its rhythm while in Persian, because the language lacks the definite article, this important feature was lost. However this was more than compensated for by Ta'liq and Nasta'liq which sweep the words along in undulating waves.

Under the Timurids and the Safavids, calligraphy experienced perhaps its most brilliant development. The Timurid princes in particular were renowned for their cultivation and patronage of the arts and at their courts they gathered the finest calligraphers, painters and poets, not to mention musicians, historians and men of learning. These princes were often poets or calligraphers themselves. Ibrahim-Sultan, son of Shah Rukh (1404–1447), who was governor of Shiraz from 1414 to 1434, had his own

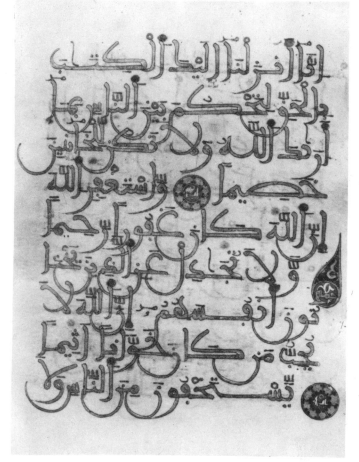

29 Koran, Islamic Spain or North Africa, 11th century. 11 × 9 in. Chester Beatty Library, Dublin. Majestic Maghribi script in gold. This koran is written on parchment, which was used for much longer in western Islam than in the east where paper had become standard by this time.

65 calligraphic inscriptions. In Safavid mosques of the 16th and 17th centuries these inscriptions are almost invariably written in the same way: pure white script on a ground of celestial blue. The colour symbolism of religious iconography is always complex but the constant use of blue and white for ceramic inscriptions—and koran frontispieces—is clearly explained by the divine and extraterrestrial associations of the two colours.

The Ottoman Turks

The Ottoman Turks, like their Safavid contemporaries, made extensive use of tiles in the decoration of mosque interiors. As in Safavid Isfahan the mosques of Istanbul included inscriptions in blue and white ceramic tile written in several forms of script (though rarely in Ta'liq or Nasta'liq), whose location however was often quite different from those in Persian mosques.

The Ottomans excelled at all forms of calligraphy, including the specifically Persian variants, and themselves invented at least one new form. Ta'liq and Nasta'liq were in fact used in Turkey for writing poetry, while religious works, the Koran, and history writing of which the Ottomans were so fond, were rendered in bold Naskh. Turkish calligraphers brought a new dignity to Naskh which it had not known since the 11th century. This can be seen at

12 its finest in the 16th-century *Siyar-i Nabi* (History of the Prophet) produced for the Imperial Library.

Also produced for imperial edification were albums of calligraphy by the most gifted practitioners of the art. Perhaps the finest Turkish calligrapher was Hafiz Osman (1642–1698) who was a master of Thuluth and Naskh. He is credited

28 with invention of the *Hilyah* or formally written description of the Prophet, a word-picture quite different from those found in both Turkey and Iran where a word or phrase is written in the form of a

35 bird or animal.

Another new and unusual use of calligraphy was the creation of an official monogram for each sultan. This was always written in the same way, though of course the name was different, and called the

37 *tughra*. The *tughra* is another example of a monarch's name becoming a heraldic symbol, and in this context we may recall a similar usage by the Mamluke sultans who were also Turks.

Under the Ottomans calligraphy virtually disappeared from domestic pottery, a development not

explained by the fact that many potters in Isnik, the centre of the 16th- and 17th-century ceramic industry, were Greek and Armenian. Ceramic calligraphy seems to have been reserved for objects where its application was entirely didactic, on mosque lamps for example.

If the handsome Naskh of the *Siyar-i Nabi* reflects one side of Ottoman Turkey, the curious Diwani (imperial) of official documents undoubtedly 36 represents another. Necessarily complex to avoid forgery, it evokes the intrigue, splendour and decay of the declining Ottoman Empire.

Islamic Spain and the Maghreb

The far western part of the Islamic world, North Africa and the southern half of the Iberian peninsula, remained virtually unaffected by the calligraphic developments in the east. Until today North Africa has preserved its own peculiar variant of the ancient Kufic script which is usually referred to as Maghribi, that is western. This was rather more 29 cursive than the old simple Kufic, and great play

31

30 Scene from the *Sulayman-Name* (History of Sultan Sulayman), Constantinople 1579. 15¾ × 10¾ in. Chester Beatty Library, Dublin. This scene showing the Imperial army in procession illustrates some of the characteristics of Ottoman painting: its concern with realistic reportage of contemporary subject-matter, its stark landscapes and hard colours. This superb rendering of overwhelming military power has no parallel in Near Eastern art outside of ancient Assyria.

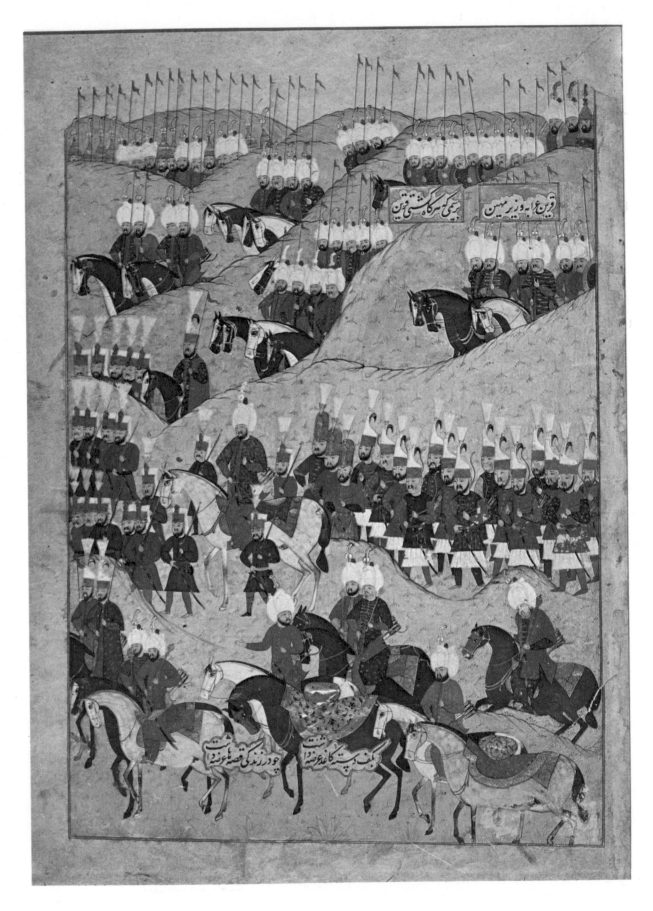

31 Ivory casket, Cordoba, 969–970? Victoria and Albert Museum, London. Large numbers of carved ivory caskets were produced in the Cordoba area during the 10th century. Judging by their inscriptions, and courtly and power theme imagery, most seem to have been destined for the royal family and nobility. This casket bears an inscription in Kufic characters stating it to have been made for the Prefect of Police. The birds and huntsman shown here are an interesting example of the representational art of Islamic Spain, much rarer than in the rest of the Islamic world.

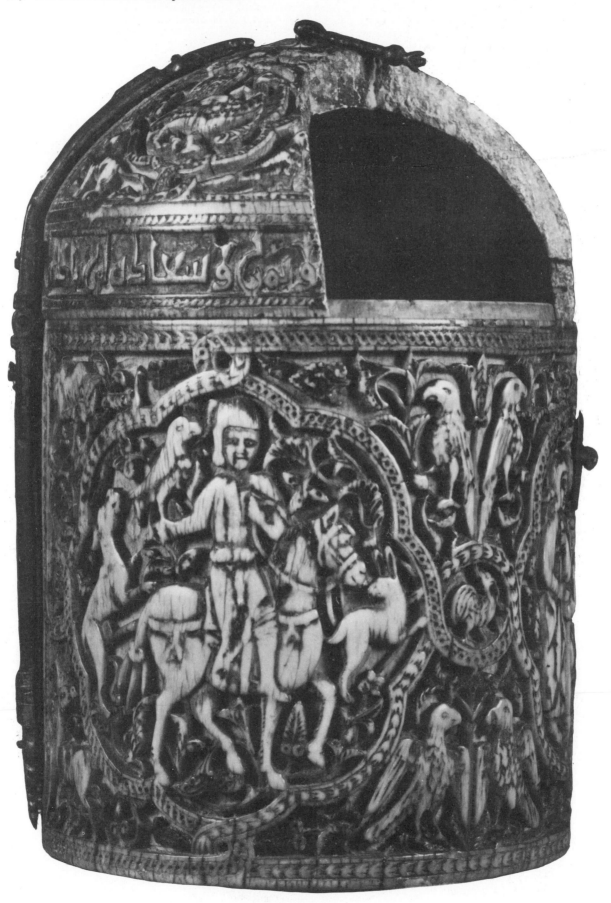

32 Ceramic plate from Kashan, Iran, dated November 1210. Diameter 13¾ in. Freer Gallery, Washington. This plate may be part of a set and is thought to depict a royal groom asleep by a pool who dreams of a water-sprite, while members of the monarch's entourage look on. The figures are set on a background of tight scrolls, illustrating an important aspect of Islamic art: space is rarely free but usually defined in some way, by a foliate-geometric background or laterally by framing devices of various kinds. The design is painted in lustre which is not only decorative but has important religious overtones, light having divine connotations for Muslims. Around the rim Persian verses are written in an early form of Ta'liq script.

33 Figurine, Rayy, Iran, 12th–13th century. Raymond Ades Collection, Surrey. The production of human and animal figurines was one aspect of the increase in representational imagery of Islamic art in this period. Their purpose is unknown, but it is suggested that they were inspired by Chinese tomb figures exported to the Near East. Sometimes the figurines were glazed in monochrome as here, at others covered in decoration like ordinary pieces of pottery.

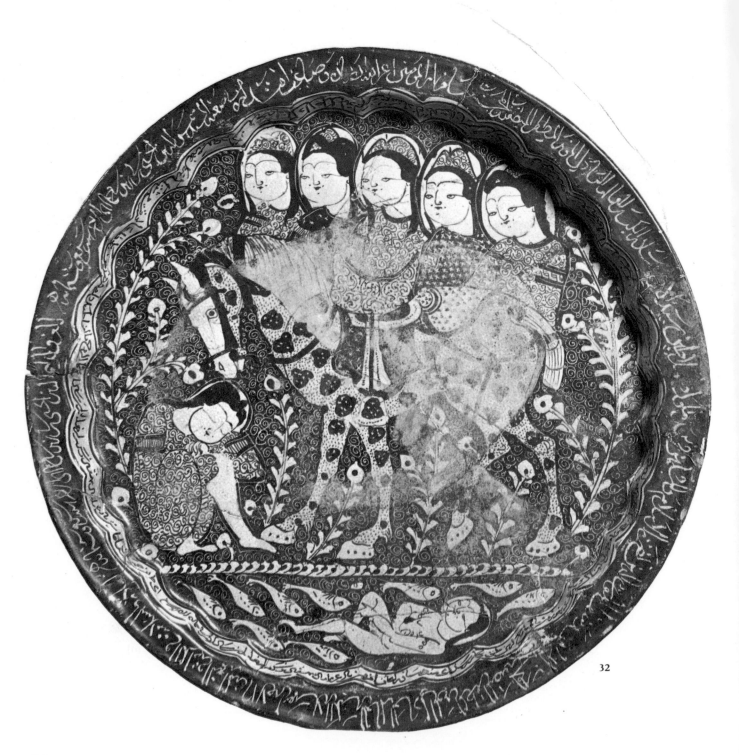

32

34 Ceramic bowl of the *minai* type from Kashan, Iran, dated 1187. Diameter 8½ in. Metropolitan Museum of Art, New York. Polychrome pottery such as this became enormously popular in Iran during the 12th and early 13th centuries. As on much pottery of this type the drawing is rapidly executed but extremely accomplished. The painting is related to those in manuscripts, though the themes of *minai* painting are generally not literary and the rapid technique is also quite distinct from manuscript illustration. The subject is not clear though winged genii are usually shown in the company of royal personages. There is a heavy inscription in foliated Kufic around the rim, and the bowl is signed by Abu Zayd Al-Kashani.

33

34

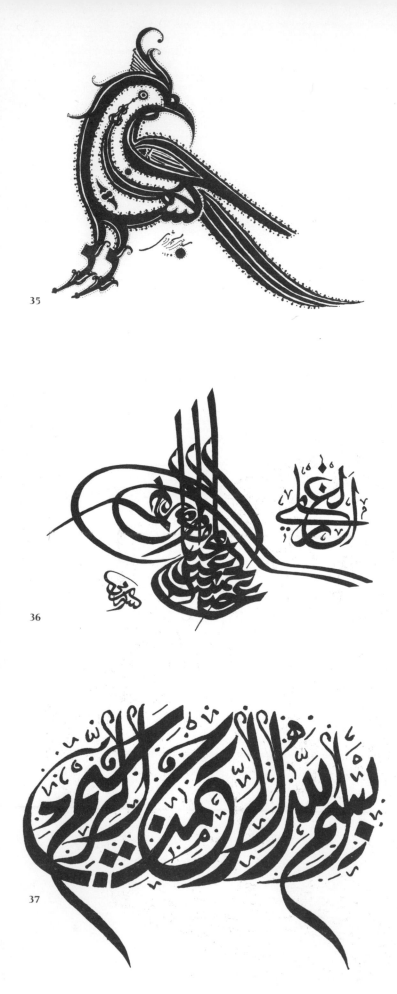

was made of transforming those parts of letters which extended below the line of writing into sweeping arcs. In spite of such innovations Maghribi is still identifiable with the script of the early korans. Following established Muslim tradition, calligraphy was employed in both Africa and Andalusia as an element in architectural, textile and ceramic design. Under the Umayyads of Cordoba (756–1031), a simple or slightly foliated Kufic was normally used for inscriptions, in the Great Mosque for example and on the numerous caskets of carved ivory. In later times, however, we find considerable use being made of plaited Kufic for the decoration of architectural surfaces—the Alhambra for instance—textiles and occasionally koran frontispieces. Plaited Kufic, used throughout Islam, was the most intellectual form of the archaic script; in it the vertical letters were plaited into knots, often extremely intricate, but without any corresponding loss of legibility. When this occurs in koran frontispieces of circular format it becomes a clear attempt to wed the evocative potential of the script, particularly if the only word written is the divine name, Allah, to the contemplative geometricity of the arabesque and as such becomes religious art of the highest order.

Both Naskh and Thuluth were used in western Islam though neither seems to have established much of a hold on popular imagination, for the Maghribi script was a vital and irreplaceable part of the Andalusian life-structure. This was not simply because the Andalusians were cut off from the influence of Iran and the east where new forms of script were popularised. The Arabs came to Spain as bringers of a superior civilisation before which the Latin culture of the peninsula virtually collapsed, where even many of those who did not convert to Islam were entirely Arabised in dress and language. Thus the form of the script brought by the Arabs in 711 was identified not only with Islam, but with its self-evident superiority over other faiths and was therefore adopted as the normal hand as well as that of the Koran.

Representational Art

The unique character of the Koran, that is its literal identification with the Divinity in the mind of the believer, meant that in its written form it occupied a position analogous to that of the icon or sacred image in other faiths. It is this fact more than any other which explains the absence in Islam of a sanctified pictorial iconography, and it thus also makes any discussion of whether the Prophet did or did not forbid painting largely irrelevant, at least in a religious context. There is no devotional imagery in the mosque in pictorial form because the necessity for such is filled by the calligraphically written verses of the Koran.

With pictorial art cut off from such an important source of patronage this might imply an absence of representational imagery in the civilisation of Islam: in fact quite the contrary is true. Islam possesses a rich and varied pictorial tradition, but one which differs from that of Christendom or the Far East in that it is exclusively secular. Artists may have executed public projects with a definite Islamic meaning (wall paintings celebrating a military triumph over the infidel and implying divine favour for the Muslim faith), miniature painters may have dealt with religious subject-matter, imbuing it with deep spiritual feeling, but neither of these had any devotional purpose and were quite outside the sphere of formal religion.

In some parts of the Islamic world, notably North-west Africa and the Arabian peninsula, representational art never became popular, though this was probably due to the absence of any tradition of figure painting and carving in those areas. Similarly there were theologians who disapproved of the reproduction of the human form on the grounds that the painter was attempting to emulate the Creator (an argument used *in favour* of painting in Mughal India!). But this attitude seems to have had little effect on the depiction of the human figure in private, and indeed public places.

Representational imagery was primarily at the service of the monarch, and for much of Islamic history the main function of the artist who specialised in this form was to portray various 'power themes': the submission of an enemy, battles, certain regal animals, the enthroned monarch, and the hunt. Excavations of the 8th-century Abbasid palace at Samarra have brought to light wall paintings in the more secluded parts of the royal residence; however it was natural that wall paintings of power themes should be displayed in the audience chamber or throne room, as their purpose was to glorify the ruler for whom they were executed. The 10th-century Arab poet Mutanabbi wrote a poem celebrating the triumph of his patron, the ruler of Aleppo in Syria, over the Byzantines, in the course of which one of these power themes is described decorating the interior of a pavilion or tent erected for the public reception of the victor. The medium in which the theme was rendered is not clear—it may have been painting or embroidery—but what is important is the official status given to artists as propagandists implied in Mutanabbi's account.

We have many examples in various media of these officially sanctioned power themes: for instance the frontispiece of a manuscript painted for the library of a 14th-century Egyptian Mamluke prince showing an enthroned ruler surrounded by his court, and the famous coronation robe of Roger II of Sicily, made by Muslim craftsmen in 1133–1134.

In addition to the power themes which form the greater part of early representational imagery, there are also certain courtly subjects: retainers, dancers, musicians, boon-companions etc. Often the objects on which these compositions occur bear inscriptions

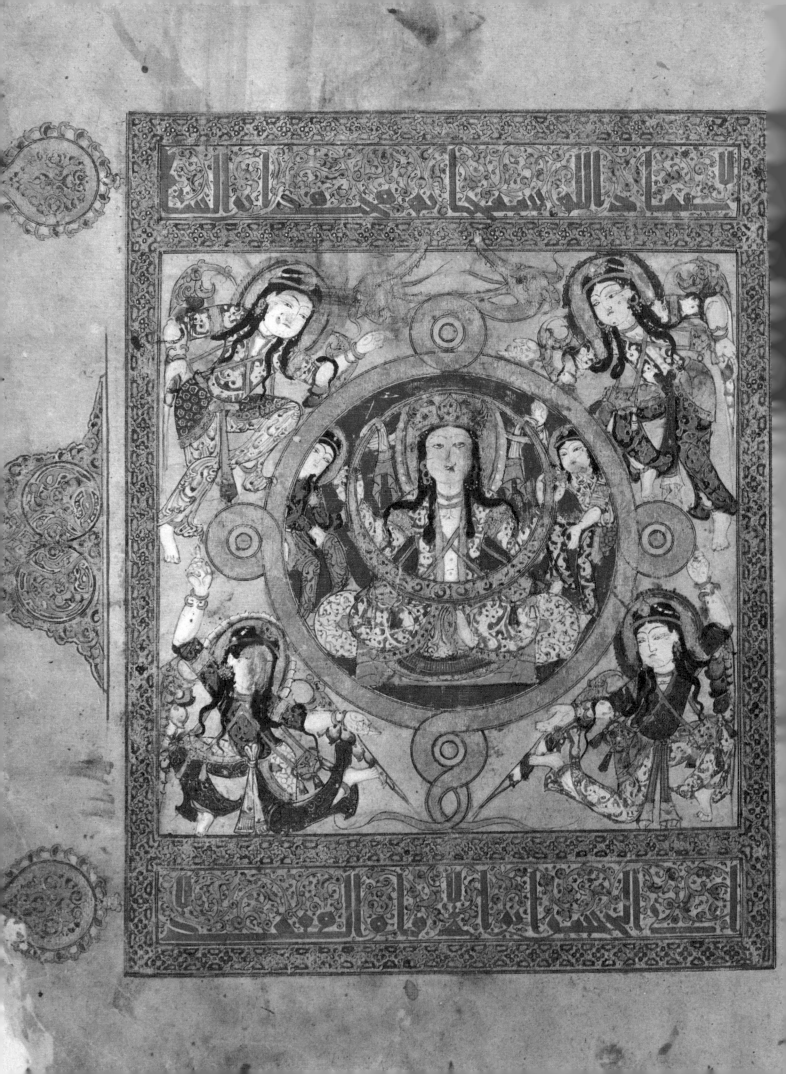

38 Frontispiece from the *Kitab Al-Tiryaq* (The Book of Antidotes), Mosul, Iraq, 1199. 7 × 7¼ in. Bibliothèque Nationale, Paris. Although this is one of the earliest dated Arabic manuscripts the painting is in a mature, fully developed style, but quite different from that of 13th-century Baghdad. The subject is not clear but is presumably magical or talismanic. Confronted and interlocking snakes and dragons have a long history in the East going back to prehistoric times. The script is a form of Kufic rather like Qarmathian. This page with its ancient magic symbolism and Islamic elements, both local and international, demonstrates some of the complexity of Islamic art.

39 Scene from the *Divan* (collected poems) of Khwaju Kirmani, Baghdad, Iraq. 12¾ × 9½ in. British Museum, London. One of the earliest examples of the high-horizon format, increasingly from now on the standard 'locale' of Islamic painting.

39

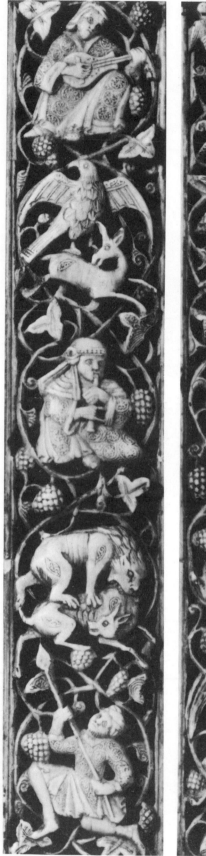
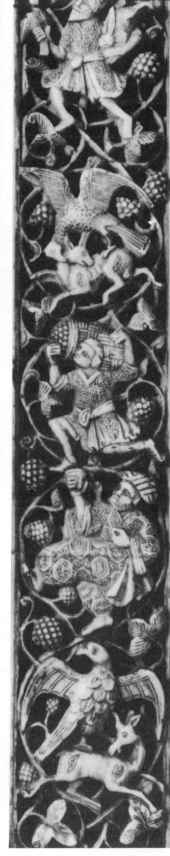

enabling us to associate them with a particular ruler or member of his family or entourage.

The imagery of early Islam was heavily indebted to the art of the conquered areas, particularly Egypt, Syria, Central Asia and Iran. It was largely from the pre-Islamic art of this latter area that the formal celebrations of royal power and splendour were adopted, a fact explained by the political and cultural transformation of the Abbasid court of Baghdad in the 8th and 9th centuries at the hands of Iranian favourites and advisers. The ruling institution of early Islamic times, the Orthodox Caliphs, and that of the Umayyads, was democratic but archaic with the ruler trying to administer the empire like a desert chieftain caring for the personal needs of his tribe. Under the later Umayyads and particularly during the Abbasid caliphate of Baghdad, administration and court protocol were transformed as a result of Iranian influence. Iran boasted a glorious imperial past stretching back to Cyrus the Great, and from the reservoir of Iranian imperial tradition much of the administrative expertise and court protocol of later Islamic times was derived. Along with court protocol of pre-Islamic Iran came some of the official iconography of the state.

Another public manifestation of figure painting was in the hammam, or public bath, where the walls were decorated with pictures of beautiful women, lovers, gardens and battle scenes. The purpose of these scenes, so we are told by a 14th-century physician, was not decorative but therapeutic. They were there to replenish energy lost in the course of languishing in the hot bath. This was achieved by stimulating the three vital principles of the body: 'the animal, the spiritual, and the natural'. Theologians may have raised objection to these pictures; nevertheless their use is widely attested, even in conservative areas like Muslim Spain.

The great bulk of figure painting, however, occurred in illustrated manuscripts. There were certain types of manuscripts for which illustration was absolutely essential: works on medicine, botany, geography, veterinary science etc., in which human and animal figures often appeared. Such works are the earliest known Islamic illustrated manuscripts.

With the exception of these early manuscripts which were probably produced for individual scholars and scientists, manuscript illustration was

largely associated with the royal courts of Iran, Ottoman Turkey and Mughal India. Many of the rulers and princes of these areas prided themselves on their fine libraries containing thousands of volumes. Each library was equipped with a large staff of artists and craftsmen whose task it was to produce manuscripts and compendia of painting and calligraphy bound in albums. Islamic manuscript painting thus mirrors the tastes of the royal courts for which it was created. In Iran it consisted of illustrations to the half-dozen great works of Persian literature led by the *Shah-Nama*, epic history of the Iranian nation. In Constantinople artists celebrated the lives and triumphs of the Ottoman sultans, while the Mughal painter was almost a court photographer, recording the contemporary life and interests of the emperors.

Prior to the 12th century, Islamic figural art in both theme and luxury media was associated with the royal court. Manuscript illustration was a possible exception, as some scientific and technical works contained drawings connected with their subject-matter. The *Book of Fixed Stars* written in Baghdad in about 965 almost certainly possessed drawings of the constellations in anthropomorphic form. Other works however, which we can presume to have been illustrated in the early period, such as the *Book of Kalila and Dimna*, a collection of animal fables, were part of the court milieu, being a polite way of telling sovereigns how to do their job.

In the 12th and 13th centuries Islamic representational imagery underwent major developments: it was applied to media where hitherto it had been virtually unknown, and new subject-matter appeared, taken from the lives of the urban bourgeoisie and lower classes. These developments are associated with the art of Fatimid Egypt, Mesopotamia, and the Seljuk areas of Anatolia and Iran.

The Fatimids

14 The two most impressive examples of Fatimid representational art are unquestionably the corona-
27 tion robe of Roger II of Sicily and the painted ceiling of the Palatine Chapel in Palermo, both executed by Fatimid craftsmen. While much of the painting on the honeycomb ceiling consists of power themes and courtly diversions, it is not exclusively so, for in addition to the musicians and dancers, servants and others from the lower ranks of palace life are introduced, if rendered rather formally. This interest in ordinary people also appears on a group of ivory carvings in the Islamisches Museum, West 40 Berlin. Although the musicians, huntsmen and servants are superimposed on a formal vine scroll they are rendered with a realism and sympathy verging on social comment: note for example the servant stumbling along under the weight of a basket of grapes directly over the portly figure of the nobleman, reeling, winecup in hand. It shows an awareness of the lot of the lower classes, even though the overall theme is obviously 'princely pleasures'. The most important Fatimid figure painting is to be found on lustreware: fascinating genre scenes (a wrestling match, cock fight etc.) taken directly from 10 the remembered reality of the street and marketplace. Although some of the scenes are rather heavily drawn in the manner of the painting in the Palatine Chapel, others have been rapidly sketched in with the tip of a brush. A great deal of this pottery was created for the rising middle class of merchants, hence the interest in new themes. Some of these passed over into the repertoire of the court artists to appear in places like the Palatine Chapel.

The Seljuks: ceramics and metalwork

Figure decoration appeared on Seljuk pottery from the mid 12th century onwards. At first the decoration was carved or moulded while the glaze was monochrome, though on the *lakabi* carved wares several colours were used. Sometimes decoration was applied directly on to the pot, painted in black slip under a clear or coloured glaze to create a silhouette effect. Large birds, animals and fabulous creatures form the bulk of the imagery, though on the silhouette ware human figures appear. The silhouette figures often stand alone though it is usual for human and animal forms, whenever they occur, to be superimposed on a foliate background.

With the introduction of the *minai* and lustre techniques figure painting on pottery advanced rapidly. The former enabled many colours to be used and the result is something remarkably like manuscript illustration, an effect increased by the frequent absence of a foliate background. The figure drawing on *minai* ware is extremely accomplished: 34 the fact that it was obviously executed with great rapidity emphasises the artist's absolute control of the brush. Such mastery of line is partly explained

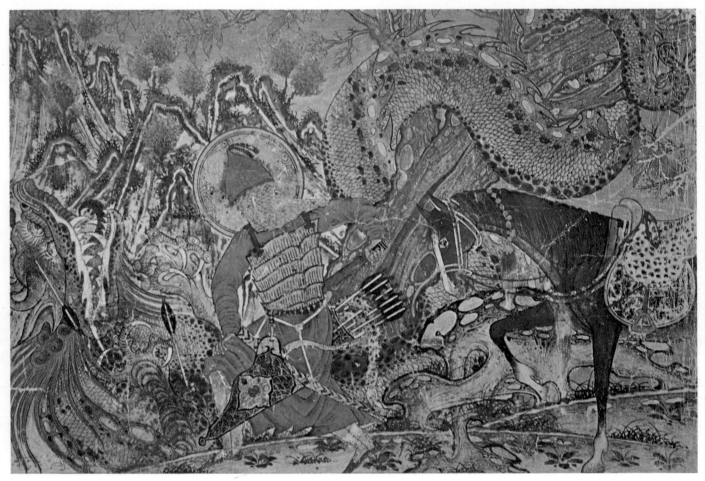

41

by the calligraphic tradition of Islam, though the only logical way this facility could be acquired was by constant practise. *Minai* painting is often taken as evidence of the existence of a thriving school of manuscript illustration in Seljuk Iran, known only by a single illustrated manuscript.

Although the compositional structures of *minai* painting are part of the Mesopotamian and Seljuk traditions of pre-Mongol manuscript illustration, the rapid graphic style is relatively little used in those traditions. *Minai* ware was in production for at least seventy years, and this of course was quite long enough for the establishment of a separate tradition of pottery painting, related to, but not dependent on, contemporary manuscript illustration. Although the figures on *minai* and lustre pottery represent a particular Turkish racial type, we need not assume that this pottery was produced solely for the Seljuk nobility; all the indications are

that it was made to be used equally by the wealthy native bourgeoisie. This applies as well to Seljuk metalwork. The scenes on the famous Bobrinski 17 Bucket made in Herat in 1163 are taken from the courtly and power repertoire, though according to an inscription the recipient was a merchant.

The same bucket shows another extension of representational imagery peculiar to this time: the intrusion of figures into the domain of calligraphy in the form of human-headed letters, and people and animals intermingling with script, a fact that indicates the strength of representational art during the period.

The popularity of figure forms led to their inclusion on the façades of buildings in Seljuk Anatolia, and in Iran to the creation of metal incense burners and pottery figurines in the shape of people and animals. The pottery figurines, which may have 33 been inspired by similar ones imported from China,

42

مقالة أولى اندر منافع من ورز

أول بذانكه چون نطفه
دزرحم ماده حاصل شود
وقوازكبد ومعزاز
قوت وحرارت
بیدا کردد واز دماغ
ودل وجگر بیاید
ونفس کلی بذان رسد
ماتند زرده خایه باشد
دم الطمث باز بندد
وهم چون سپیده خایه
نرا منشر درآید جنابک

بنیر مایه اندر سبیز تازه بن علقه کردد ماه اول دزتدبیر زحل باشد وازبهرانك طبع زحل و نظفر

are sometimes glazed in solid colours, at others covered in foliage and even other figures, as if no distinction was made between the decoration of figurines and utilitarian pottery. This can be explained in several ways, however. A foliate or geometric 'environment' superimposed on a figure would appear to be directly related to the converse situation, common in Islamic art, a figure superimposed on a foliate or geometric background. Perhaps the rigid control of space that this implies should be understood in terms of the total Islamic 'world vision' of a society living according to the dictates of divine law, existing in a controlled, ordered universe which functions according to divine command. Thus the space of a painting, or the surface area of a pot or piece of metalwork, is rarely free but usually defined and controlled in a reflection of the cosmic order. For example, even though foliate backgrounds have disappeared from many *minai* bowls, we will normally find the figures inhabiting them compartmentalised into geometric areas or, if this is absent, it is only because the bowl itself is treated as a spatial unit and its perimeter closed by calligraphy, decoration or a simple line.

Mesopotamia

In 12th- and 13th-century Mesopotamia there were two important centres of artistic production: Mosul in the north, and in the south Baghdad, capital of the now greatly reduced Abbasid caliphate. In Mosul there arose an important school of metalwork, known to us by a number of signed and dated pieces of quite outstanding workmanship. There is a certain amount of Seljuk influence in this metalwork, presumably brought by emigré craftsmen from Iran, particularly after the Mongol invasion. Like Seljuk metalwork, that of Mosul made wide use of figure decoration and in fact very few pieces without figures are known. Power and courtly themes abound, though once again there is no evidence that this metalwork was wholly produced for the local court. Some was, however, and bears the name of the ruler of Mosul, Badr Al-Din Lu'lu' (1233–1259).

We can associate some of the illustrated manuscripts written in Mosul with the same man. Several of the manuscripts produced in Mosul for Badr Al-Din, and earlier ones from the same place, depict figures with distinctly Seljuk-Turkish features. Presumably in Mosul as in contemporary Persia these features represent an ideal type, for the city was not controlled by the Seljuks and Badr Al-Din was actually of Armenian origin.

Another group of illustrated manuscripts is usually attributed to Baghdad. These are copies of the Arabic work called the *Maqamat* (Assemblies) of Al-Hariri. The miniatures in these manuscripts are among the most impressive paintings of the entire Middle Ages. They represent the culmination of the tendency towards naturalism referred to above, and give a complete picture of life among the urban bourgeoisie of the 13th-century Islamic cities. It is strange that the *Maqamat* was chosen to be the vehicle for such a series of portraits of urban life, for the text is really an exposition of the niceties of the Arabic language and rather unsuitable for illustration. The explanation, it has been suggested, is related to the whole phenomenon of 12th- and 13th-century figurative art: that the urban middle classes developed a taste for representational imagery which they wanted to see reproduced in all media, including their favourite work of literature.

In addition there seems to have been a desire on the part of the *Maqamat* illustrators, presumably in answer to the demands of their patrons, for the creation of a far more elaborate form of image. We find them initiating a period of daring spatial experiment, in the course of which the simple miniature composition of a group of figures tied to a base line was entirely transformed. Compositions were expanded over two pages and then enlarged to fill a double page. They also were extended upwards in a way that contains hints of the third dimension, probably explained by a dependence for models on local Christian iconography in which traces of the type of perspective used in Antiquity had been preserved in a formalised fashion.

The Mamlukes

Representational imagery was used in the art of the Mamlukes in both manuscripts and metalwork. On metalwork arabesque decoration and calligraphy gradually became prominent, but not before some magnificent figure decoration had been produced. Manuscripts continued to be illustrated throughout Mamluke times. The figures in these illustrations are rather stiff and formal, quite unlike those of Baghdad, and often set on grounds of solid gold which give them a rigid hieratic appearance. Nevertheless some extremely fine animal painting occurred

in works of natural history.

As a military caste the Mamlukes were greatly interested in works of warfare, many of which were illustrated, often only with diagrams but in several works with good quality miniatures.

Iran: developments after the 13th-century Mongol invasion

Persian miniature painting begins with the Mongol Ilkhanid dynasty. The later Ilkhanids tried to repair some of the destruction caused by their devastating invasion in the early 13th century; they built new cities and employed able native officials to administer the country.

Illustrated manuscripts were produced for the Ilkhanids and for their successors who controlled Iran and Mesopotamia until the conquests of Timur (Tamerlane) at the end of the 14th century. Painting begins with artists still following the Mesopotamian and Seljuk traditions where figures were tied to the base line on a blank or single-colour background. However, because the Ilkhanids had close links with China, Persian painters were exposed to the stimulating influence of Chinese works of art and perhaps even Chinese painters working at the Ilkhanid court. These contacts helped to bring about an era of genuine experiment which makes the 14th century one of the most exciting periods in Persian painting.

Some of the effects of Chinese influence can be seen in the picture of *Bahram Gur's Battle with the Dragon* from the famous Demotte *Shah-Nama*, illustrated in Tabriz in the second quarter of the century. The mountains and landscape details are of Far Eastern origin as of course is the dragon with which the super-hero is locked in combat. Less obvious, but more important, is the vague undefined relationship of immediate foreground to distant background, and the abrupt cutting off of the composition on all sides. Chinese painters always left space imprecisely defined, with large areas of landscape untouched by the brush, and the extremities dissolving into thin air to create the impression of an ever-expanding vista.

But the unlimited freedom of Chinese pictorial space was so fundamentally at variance with the Muslim psyche that, although Persian painters experimented with it on a limited scale, ultimately it was the idea of defined space that reasserted itself in the 'high-horizon' composition which emerged

43 Inlaid brass ewer, Mosul, Iraq. 1232. Height 12 in. British Museum, London. Mosul was one of the most important centres of metalwork production in the late 12th and early 13th centuries. Calligraphic and abstract elements are extensively used in the decoration but the majority of pieces are dominated by figurative imagery.

at the end of the 14th century to become the basic format of painting throughout Islam for the next several hundred years. It was not simply that the confined locale of this format was psychologically 'safe', it was the application of the principle of universal order to the visual arts as it was applied to poetry and music; in other words, that there was a definable aesthetic order or framework in which the artist operated—a specific number of modes for the musician, certain themes and metres for the poet, and a standard format for the painter. Once the basic framework had been mastered personal interpretation became possible: not freedom in our modern sense, but extemporisation within the formal structure of the art. For example, in the case of the painter, personal interpretation included the way in which the composition cut the surrounding border; it may have billowed out on three sides yet on the fourth remained firmly anchored in the traditional format.

46

44 Scenes from the *Khamsah* (Five Poems) of Amir-i Khusrau, Herat, 1485. 6¾ × 4½ in. Chester Beatty Library, Dublin. A fine example of the form of classical painting developed and refined at the courts of the Timurid rulers of Iran. The delicate naturalistic detail of the landscape, and the proportion of the figures to the high-horizon format are typical of the period. The composition is one of the simplest in this manuscript, and relies for its effect almost entirely upon an extremely subtle harmony of colours.

45 Scene from the *Khavar-Nama*, Iran. 15¾ × 11½ in. 1477. Chester Beatty Library, Dublin. The work is a poem dealing with the exploits of Ali against the Kings of the East. This scene shows Mir Sayyaf in combat with a King of the East. The paintings in the manuscript are the earliest and finest of the Turkoman school, which lasted well into the 16th century and whose centre was probably Shiraz in southern Iran. The painting is 'utilitarian' in character, using stock images and standardised backgrounds.

46 Drawing by Muhammadi, Iran, 1575. 8 × 4¼ in. Chester Beatty Library, Dublin. In the second half of the 16th century independent drawings became popular. They were executed in a fine wiry line, often with small areas tinted or painted—like the melon patch here. Towards the end of the century the style of drawing changed significantly, and the quiet, poetic charm of Muhammadi was superseded by a boldly assertive calligraphic form.

The establishment of the new high-horizon format coincides with the disappearance of the minor kingdoms into which Iran and Mesopotamia had been divided with the decline of the Ilkhanid empire. It was during the final years of one of these statelets, that of the Jalayirids of Baghdad (1336–1411), that the most spectacular early examples of high-horizon miniature occur in a manuscript painted in Baghdad in 1396, the *Divan of Khwaju Kirmani*.

The Timurids

At the end of the 14th century Iran was incorporated into the domains of Timur, and during the next hundred years, thanks to the enthusiasm of certain Timurid princes, painting entered its finest, classic phase. The development of the classical style is first associated with Shiraz under the governorship of Iskandar-Sultan (1409–1414), a grandson of Timur, then with the capital Herat where it was patronised by Prince Baysunqur (1397–1433), bibliophile son of the Timurid monarch Shah Rukh, and finally with Sultan Husayn Bayqara (1468–1506), last Timurid ruler of Herat. It is this style with its rectangular format, approximate 5:1 proportion of figures to background, and fineness of detail that most people regard as typical of Persian miniature painting.

The classical painter deals in perfection: his landscape is a garden in springtime, his interior a sumptuous palace, his subjects idyllic and heroic. But he is no illusionist; the elements of his universe are shown exactly as he knows them to be, not as they appear to the eye, distorted by momentary optical and atmospheric effects. He is a narrator with absolute powers. He can open up the ground to show the events in a subterranean chamber, and can illuminate a nocturnal meeting with the brilliant light of noon.

His universe is clearly defined and reassuringly tangible, and it is through his description of the universe and the elements that inhabit it that his personal contribution is made, and his individuality as an artist emerges. The painters of Baysunqur rendered naturalistic detail with painstaking accuracy. Bihzad, the master-painter of Sultan Husayn's Herat, introduced a new realism of iconography and an individualisation of figures by age, physical type and psychological involvement. But above all it was through the search for ever more perfect harmonies of design and colour that the artist projected himself.

Outside the mainstream of classical painting other forms existed, each with its own nuance of style. While Baysunqur's artists worked to perfect the classical style, those of his father, the devout Shah Rukh, produced strange illustrations of apocalyptic and mystical visions. And in western Iran, as the Turkomans encroached, a new form of 'utilitarian' painting arose in that area, called after the conquerors the Turkoman style.

The Safavids

Herat was captured by the Uzbegs in 1507 and many of the court painters carried off to their Central Asian capital, Bukhara. Some three years later the Uzbegs were defeated by the Safavid armies advancing from the west, and Herat occupied by Shah Ismail. All the painters remaining in the old Timurid capital were transported to the Safavid court in Tabriz. Thus the classical style of painting was to continue in existence for some considerable time yet. Bihzad's influence was strongly felt in the painting produced in Tabriz, although the master himself was probably taken to Bukhara by the Uzbegs and did not appear in Tabriz until 1521. In the work of some of the best Tabriz painters, notably Mir Sayyid Ali, the realistic aspects of the classical style are brought to perfection and some of his scenes seem based on genuine observation.

During the 16th century the Safavid capital was changed twice to locations further away from the western border with the Ottoman Turks, who were bitter enemies of the Safavids. In 1548 the court moved to Qazvin and in 1589 to Isfahan, and with each new capital there was change in the course of metropolitan painting.

Persian miniature painting had always been heavily dependent upon royal patronage. Obviously the cost of production and materials was so great that only a ruler or rich prince could afford to maintain the necessary team of master craftsmen, calligraphers and painters. Therefore when in the mid 1540s the reigning Safavid sovereign, Shah Tahmasp, withdrew his patronage this had serious consequences. Many of the best artists left the court, some going to Bukhara, others to India where they were instrumental in the formation of a new style of painting, the Mughal school. Those artists who remained turned from the production of lavishly illustrated manuscripts to separate drawings and miniatures for less wealthy patrons. However the

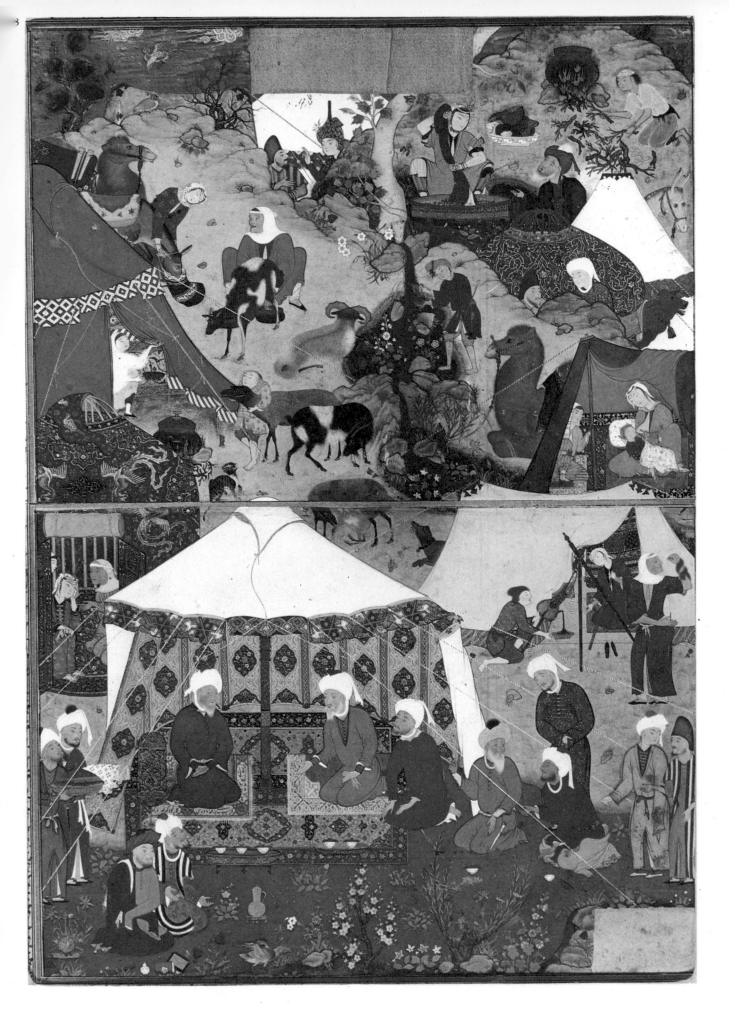

47 and 48 Scene from the *Khamsah* (Five Poems) of Nizami, Tabriz, Iran, about 1540. 10¾ × 7½ in. Fogg Art Museum, Cambridge, Massachusetts. This is a double-page composition illustrating the preparations for the betrothal feast of Layla and Ibn Salm from the poem of Majnun and Layla. The painting continues the best humanistic aspects of 15th-century Herat painting, in which genuine observation is not subordinate to decoration. The artist is Mir Sayyid Ali, who later emigrated to India and had a formative influence on Mughal painting.

real change that overcame painting and drawing during this period, and became even more pronounced after the move to Isfahan, was the emphasis placed on personal handling. This emerged not only in the traditionally personal areas, such as the overflow of the landscape into the area beyond the frame (now almost total), but in elements within the landscape itself, like the heavily modelled rock formations and the dark stippled green of the ground underneath. Figures became winnowy and there is an element of caricature in their features.

Towards the end of the century the representation of the human figure became entirely transformed; this was particularly so in drawing. Before the pigment was applied to paintings, the composition had always been drawn in with a fine wiry line, and when separate drawings became popular in the mid 16th century this technique was continued. Excellent examples appear in the work of Muhammadi, whose tinted drawings of pastoral scenes were greatly prized. But in the second half of the century a bold slashing calligraphic style appeared in which forms are delineated with sweeping strokes, alternately thick and thin, reminiscent of Nasta'liq script. This style is associated initially with Sadiqi-Beg, librarian of Shah Abbas the Great (1587–1627), and then with Riza-i Abbasi, leading draughtsman-painter of the Isfahan school, whose work dominates the first half of the 17th century.

If earlier painting had been about man in his natural environment, late 16th- and early 17th-century painting is about man himself. The work of this period is dominated by large-scale representations of lovers, pretty young men and voluptuous women. There is a fashion for the sensuous and erotic and a concern with the tactile quality of hair, fur and material. In the drawings of Riza, the instant description of basic shapes is accompanied by an obsession with pleats and folds which normally serve to emphasise the sensuous curvature of bodily form, but on many occasions reach the point of pure abstraction. In a country with a powerful calligraphic tradition, writing and drawing are always interconnected, but at this time the link seems to have been particularly strong so that drawing actually takes on the physical appearance of Shikastah or Nasta'liq calligraphy.

During Safavid times painting seems to have had some influence on textile and carpet design, for we find figures and animals reproduced which resemble, stylistically at least, those in contemporary miniatures.

Mughal India

Europeans feel at ease with Mughal painting and this is understandable; it comes from an area with a long-established three-dimensional tradition and was the only form of Islamic painting to digest successfully the lessons of Western art. It was based on the traditions of 15th- and early 16th-century Persian painting brought to India by a number of outstanding émigré artists, and influenced by the actions and attitudes of some of India's most able rulers, the Mughal emperors Akbar (1556–1605), Jahangir (1605–1627), and Shah Jahan (1627–1659).

The former, as part of his general policy of accommodating the Hindu majority of the state, encouraged the fusion of Persian and native Indian artistic traditions in the painting of the court, thereby encouraging the best humanistic and realistic aspects of the classical Persian style and playing down the impersonal stereotyped image and purely decorative colour schemes. There is an individualisation of people and animals, and this extends to landscape details. Even the traditional spatial format of the high horizon begins to relax with the introduction of miniature scenes along its upper edge. Mughal painting of this time reflects the humanistic outlook of Akbar himself.

As Jahangir followed the religious policy of his father, Hindu-Muslim collaboration in the visual arts continued. However, as the emperor was a man of insatiable scientific curiosity, the court painters were encouraged to adopt a style of almost photographic realism. The artists' concern with their immediate surroundings led to the creation of intimate genre scenes and ultimately to portraiture. Western works of art brought to the court by foreigners stimulated an existing interest in free space and solid form. The result was an art of genuine representations of historical personages moving and breathing in real space, quite unlike anything we find elsewhere in the Islamic world.

The Ottoman Turks

Turkish painting was produced almost exclusively for the Imperial Library in Constantinople. It was first regarded as a mere transplant of 15th- and

49 Drawing by Riza-i Abbasi, Iran, early 17th century. 6½ × 4¼ in. Freer Gallery, Washington. A fine example of the calligraphic style of drawing. Parts of this scene, showing a tailor, have reached the point of total linear abstraction.

page 54
50 Scene from a copy of Assar's *Mihr u Mushtari*, Bukhara, 1523. 10¾ × 6½ in. Freer Gallery of Art, Washington. Paintings in the late classical style of Herat were produced in Bukhara under the influence of artists taken there by the Uzbegs. This scene showing the marriage of Mihr and the Princess Nawhid is also interesting for its mildly erotic content. Erotic themes occur throughout Islamic literature, and there is a corresponding (though little known) tradition in painting and drawing.

page 55
51 Scene from the *Haft Aurang* (Seven Thrones) of Jami, Meshhed, Iran, about 1556–1565. 13½ × 9¼ in. Freer Gallery of Art, Washington. The painter has used the simple episode of Majnun before Layla's tent to create an extravagant panorama of camp life. The element of caricature and the supple winnowy figures are typical of later Qazvin painting. The composition has expanded beyond the frame at all points, leaving only a hint of its existence at the top right. As painters worked within the fixed high-horizon format, the way in which they exceeded its boundaries was one means of making their personal contribution: only rarely is it made as dramatically as here.

16th-century Persian miniature painting, but like the art of Mughal India should be considered quite independent. We find the same high-horizon format and absence of optical and atmospheric effects, but as these are common to virtually all Islamic painting, we should expect the peculiarly Turkish contribution to manifest itself in other areas.

This is found first in the choice of subject-matter. The personality of Ottoman painting emerges in the great triumphal and ceremonial works of the 16th century, recounting the conquests of the Imperial armies in Europe and Asia and describing the festivals of state. In works like the *History of Sultan Sulayman* and the *Sur-Name* (Circumcision Festival), 30 the illustrations take the form of realistic reportage of contemporary events. Colours are hard and bright, while the romantic landscape of Iran is replaced by a simple terrain, austere yet topographically accurate.

Perhaps the finest painting occurs in the huge series of miniatures depicting the life of Muhammad, the *Siyar-i Nabi* (Life of the Prophet). These 12 illustrations display the same fundamentalist intensity of religious feeling that we find in the best Ottoman calligraphy and decoration of the 16th century.

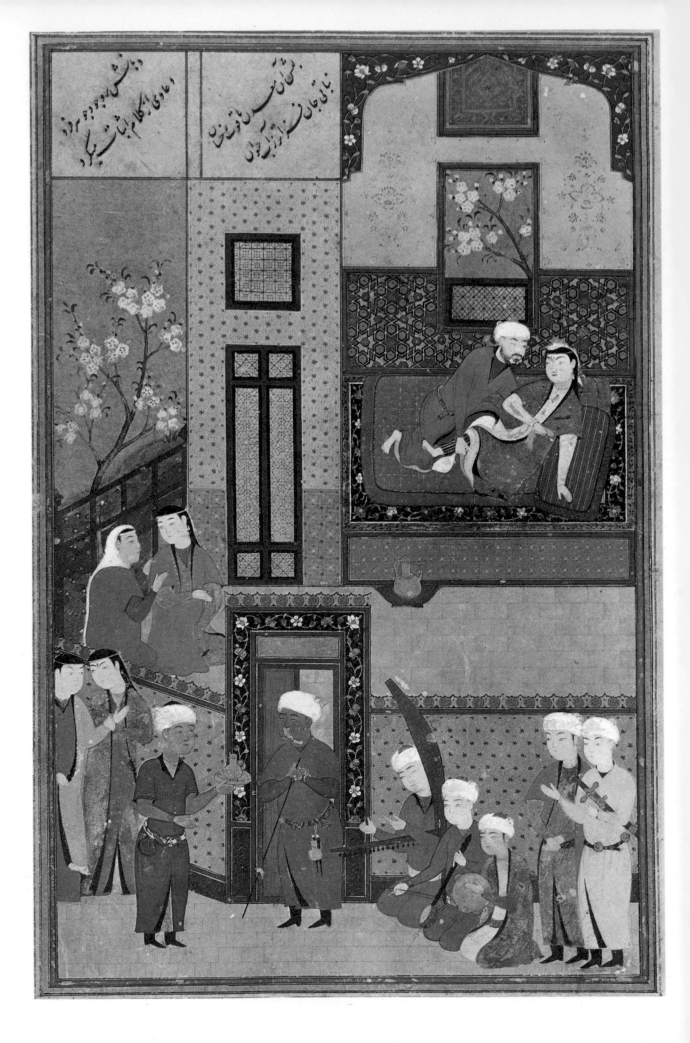

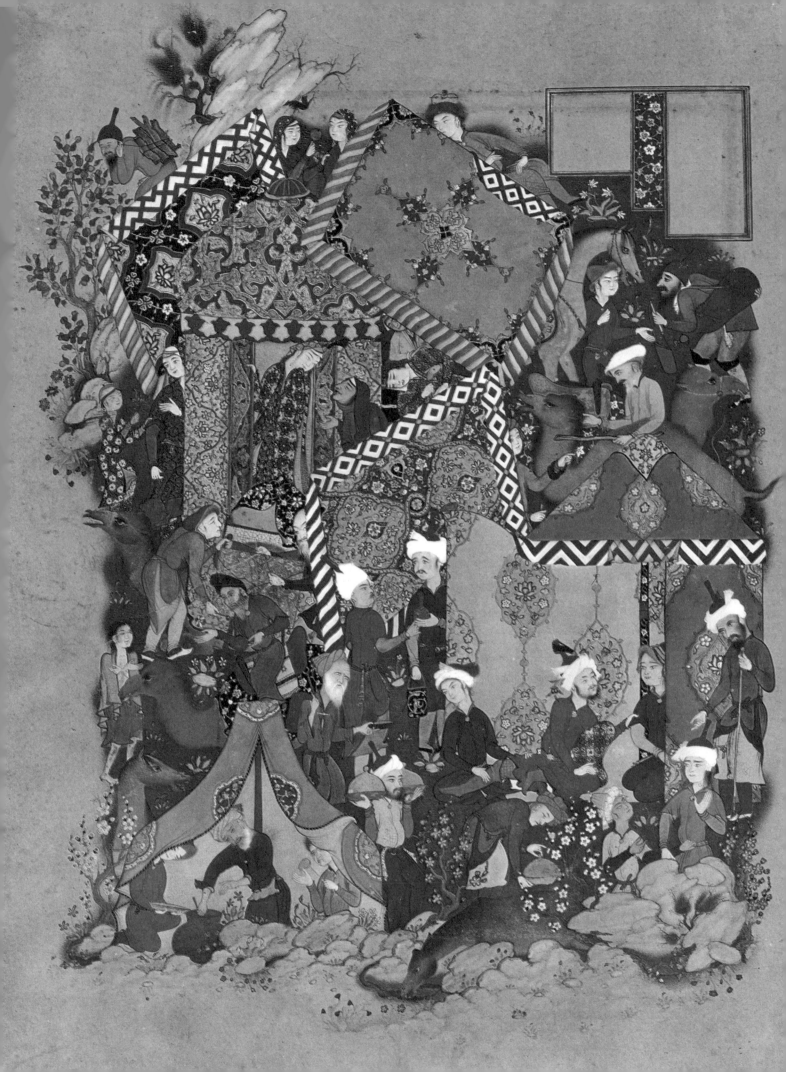

Non-representational Art

Islamic non-representational art was long considered by Europeans to be simply decorative, existing only because Muslims were forbidden to paint anything else. In fact the floral and geometric motifs that appear on the prayer mat, the koran frontispiece and tile faience interior can be identified with specifically Islamic concepts, and as such transcend the merely decorative to reflect important aspects of the vital life-structure of the Islamic community of believers. This is one level. When used with a more individualistic art form like pottery, non-figurative decoration may have, in addition to its metaphysical value, magical and talismanic connotations. In medieval times magic and the supernatural often existed just below the level of orthodox belief, and in popular imagination there was no contradiction between the two. Thus a pot or piece of metalwork may be inscribed with the traditional Islamic invocation of blessing, and at the same time be reinforced – just to be safe – with a magical symbol of remote origin.

It is not known when the Islamic state first formulated its artistic policy, but some decisions regarding the use of art in religious structures must have been arrived at in early Umayyad times, for we find non-representational decoration, along with calligraphy, used extensively in the interior of the Dome of the Rock. This decoration is made up of elements taken from the repertoires of pre-Islamic east-Meditertanean and Persian art. That a new civilisation should express itself through an ancient art is not as surprising as it at first appears, for Islam had an enormous assimilative capacity. Just as the existing Greek and Iranian civil services, monetary systems and even local customs were taken over and

Islamised, so was much of the art and architecture of the conquered areas. The Arabian Muslims who established the new faith in Iran and the Mediterranean, as far as we know, possessed only the most rudimentary forms of visual art, not because their aesthetic sensibilities were undeveloped, but because these had traditionally expressed themselves orally through poetry and rhetoric. Furthermore, after the coming of Islam, much creative artistic energy was channelled into calligraphy. Thus when it was decided to employ art in the service of religion, historical circumstances decreed that the forms already in existence all around be used. Undoubtedly the fact that Islam considered itself the primordial religion of mankind helped it to assimilate the art associated with earlier faiths. So thorough was the process of assimilation that today we immediately identify the floral and geometric arabesque with Islam, without realising that many of these abstract themes and patterns originated in Coptic Egypt, pre-Islamic Syria and Iran, and among the nomads of Central Asia.

In secular decoration from the earliest Umayyad period, figure painting, carving and even free-standing sculpture were all employed along with floral and non-figural forms, facts which are known from archaeological and literary evidence. Religious decoration however was always abstract. Quite deliberately and for sound theological reasons only calligraphic inscriptions and non-representational art were employed in the mosque and other sacred edifices. Because God was believed to be beyond description, it was thus impossible to represent Him in finite, human terms. The Prophet, it is true, was credited with saying that God created man 'in His

form' but this, it has been pointed out, can only be taken to mean that man possesses faculties which reflect divine qualities, and does not imply any other resemblance. Similarly, although the perfection of Muhammad (and all earlier prophets) was unquestioned, his sole function was to reveal God's plan and see it put into effect. To emphasise the messenger (which is what the Arabic word for prophet really means) by putting his picture in the mosque would have been quite irrelevant and may even have distracted attention from the message, that is the Koran, which was displayed everywhere. The Prophet's name, and sometimes word-pictures of him, did eventually appear in the mosque but this was a relatively late development. Devotional imagery however, if that term can be used in this context, did exist in profusion; verses of the sacred text, accepted by Muslims as the eternal manifestation of the Divinity, appeared everywhere.

The purpose of art in the mosque was therefore to create suitable conditions for worship, whereby the divine presence established by the Koranic texts could be acknowledged by the community and contemplated by the individual. These aims were achieved both in the design of the mosque itself and by applying forms of decoration. On the one hand the latter created a perfect equilibrium by simple repetition, yet on the other, because they were not closed patterns but could be continued in the imagination indefinitely, created a feeling of infinite order. Furthermore, because floral forms, which were a prominent part of the decoration, had distinct associations with Paradise, the believer could be brought to contemplate the goal of existence.

The appearance of identical decoration in mosque, mausoleum, private dwelling and palace need not surprise us, for almost no form of geometric or floral decoration was specifically associated with either domestic or religious architecture. We can explain this by pointing to the theoretic unity of Church and State in Islam; just as the chief mosque of any city was built next to the governor or caliph's palace in a visible demonstration of this unity, equally there was one form of decoration for both. The spiritual, contemplative quality of an arabesque pattern is always there in potential. This potential may be realised when the decoration occurs in the mosque in conjunction with Koranic calligraphy, it may lie submerged in the palace as the background of an animal or figure frieze, but it never disappears.

Architectural decoration

From the earliest times geometric and foliate motifs were used in the same building. In the Great Mosque of Damascus built by the Umayyad caliph Al-Walid (705–715), the soffits of the arches are covered with floral scrolls and plant forms in mosaic, reminiscent of the decoration in the Dome of the Rock, while the window grills are geometrical. In later architectural decoration separate geometrical shapes are combined with foliage. The Umayyad palace in the Syrian desert called the Mushattah, built in the first half of the 8th century, has a richly carved facade in which vine and acanthus scrolls are set inside triangles, octagons and lobed hexagons. The plant forms of the Mushattah are still naturalistic in conception but when the same geometric-foliate format occurs again in Samarra, built in the following century, the naturalistic aspect is considerably reduced.

Samarra was built as a new capital by the Abbasid caliph Al-Mutawakkil (847–861), in order to put an end to the constant friction between the Turkish troops of the army and the citizens of the old capital, Baghdad. Excavations carried out in the ruins of Samarra, abandoned in about 883, reveal three types of decoration: styles A, B, and C. The first two are similar to that of the Mushattah, but with the floral element within the geometric shapes becoming progressively more stylised.

The other type of decoration, style C, was the first example of Central Asian influence on Islamic art, obviously brought by the Turks of Al-Muta-

53 Painting by Riza-i Abbasi, Isfahan, Iran, 1630. 7 × 4¾ in. Metropolitan Museum of Art, New York. Riza-i Abbasi was the leading master of the 17th century and this picture of two lovers is one of his most accomplished pieces. From the end of the 16th century the human figure becomes increasingly more important. Subjects and treatment are sensuous and there is a concern to render material as realistically as possible. Drawing and painting have a vigorous, calligraphic quality, always present in Persian art but now much more pronounced.

54 Silk with figurative pattern, Iran, 16th century. 47½ × 26½ in. Metropolitan Museum of Art, New York. The design here appears to be inspired by miniature painting. In Safavid times painters became directly involved in the production of textiles and carpets. This resulted in the decline of carpet design which became little more than a woven picture.

55 Ceramic mosque lamp, Isnik, Turkey, dated 1549. Height 15 in. British Museum, London. The lamp was made for the Dome of the Rock, Jerusalem, and dates from the time of alterations made to the building by the Ottomans. A fine example of Isnik pottery and particularly important for an inscription on the lower rim linking it with Isnik. Calligraphic inscriptions are relatively rare in Isnik pottery and for the most part confined to mosque lamps.

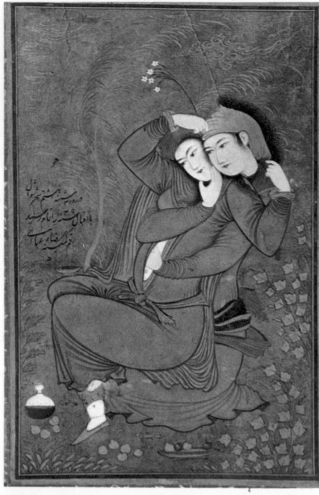

53

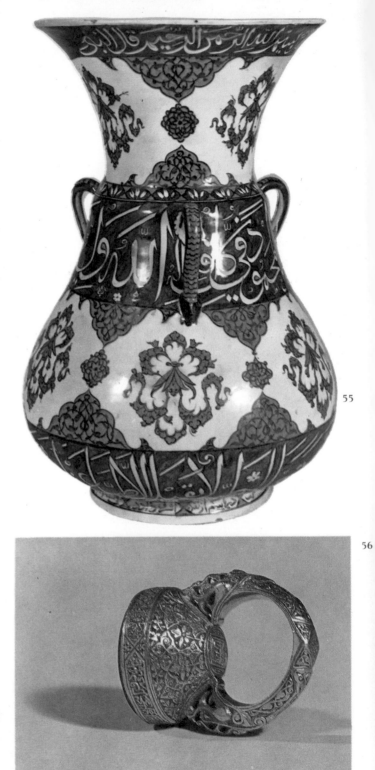

55

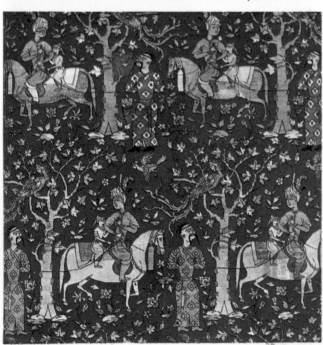

54

56

56 Gold signet ring with jade seal-stone. Timurid, about 1430. Diameter 1 in. Metropolitan Museum of Art, New York. Calligraphic inscriptions and arabesque designs are employed to cover even the smallest surface. Here, as is often the case with metal objects, representational forms are introduced: the familiar motif of confronted dragons. This ring is one of the few surviving personal ornaments in precious metal known to us.

57 Karatay Madrasah, Konya, Turkey, 1251. The portal and interior chamber behind are excellent examples of the type of decoration practised by the Anatolian Seljuks. There was a long-established tradition of stone-carving in this area, but the swastika and braid motifs, and interlocking polygonal shapes, were brought from Iran where they appear in Seljuk brickwork, and ultimately go back to Central Asia. The interlace and intersecting arch designs, in marbles of two different colours, were derived from the architectural decoration of neighbouring Syria.

57

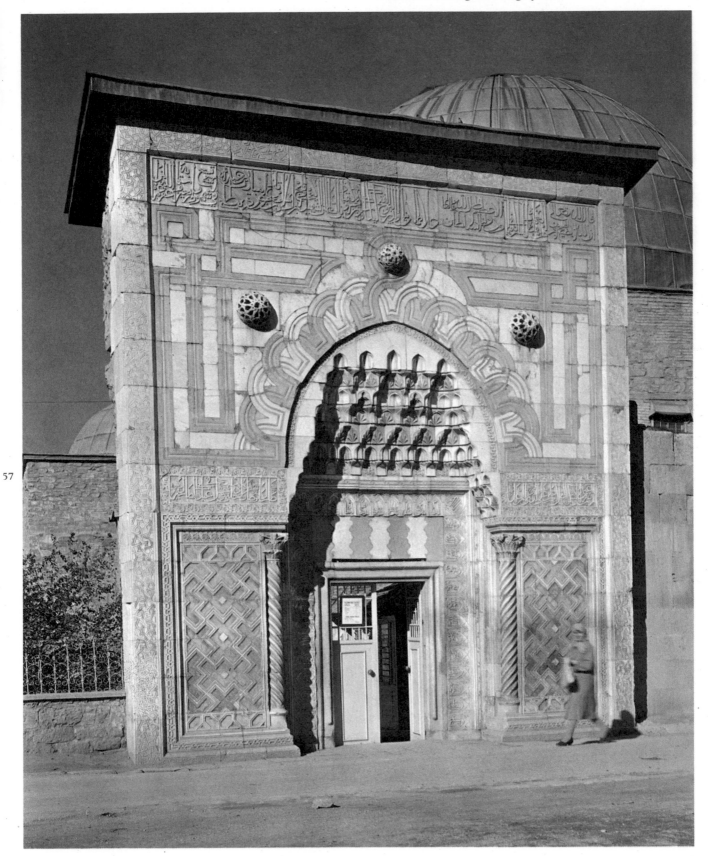

Other pieces of irregular shape, each carved with a self-contained floral motif, are slotted into the spaces between the main design.

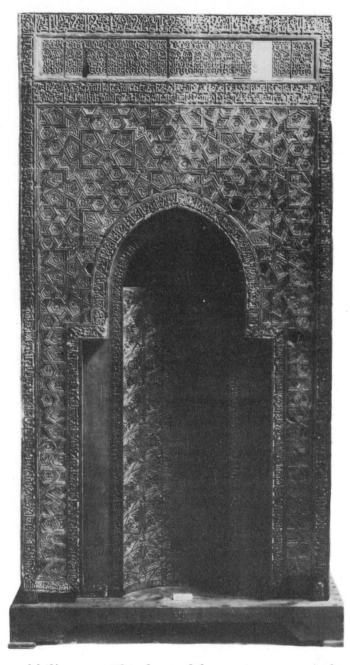

thing very like it is found in the mausoleum of Shaykh Muhammad bin Bakran, the Pir-i Bakran 66 (1299–1312) at Linjan near Isfahan.

The combination of geometric and floral arabesque, which we regard as so typical of Islamic art, appears in its earliest developed form in the art of Fatimid Egypt, particularly in woodcarving. From Tulunid times (868–905), Egyptian craftsmen had followed the artistic tradition of the Abbasids, best seen in the decoration of Samarra. Under the Fatimids the old bevelled style continued for some time, but gradually the carving became deeper and the scrolls and tendrils finer and more cursive. A fine early example of the floral-geometric complex is the carving of the mid 12th-century mihrab of Sayyidah Ruqayah, where multiple lines intersect 58 to make polygonal shapes containing fillets of wood carved with foliate designs or inset with bone. Whether large or small these complexes were made in the same way; the fillets were carved independently and the linear sections cut in short straight sections and then the whole construction slotted together.

The same tradition and methods continued under the Mamlukes, though there was an increased preference for star-polygons. Star-polygons separated by intersecting rectangles had already appeared on the mihrab of Sayyidah Ruqayah. In later Mamluke work however, the stars are allowed to grow until 6 they make contact. In addition, the fillets start to include Far Eastern elements like peony blossoms which came into Mamluke decoration by way of Mongol Iran.

One of the most dramatic uses of the floral and geometric complex occurs in Mamluke architecture. Many of the domes of the 15th-century Mamluke tombs outside Cairo are covered with enormous arabesque patterns; some are purely geometric but others like that of Qayt Bay use geometric and floral forms. The decoration on the Madrasah-Mausoleum of Qayt Bay (1474) is quite different from the earlier 64 examples of the floral-geometric complex as here each form has an independent existence. Instead of the floral arabesque pattern being composed of separate units within the geometric linear intersections, it now grows down from the apex of the dome, the geometric arabesque being superimposed on it. This superimposing of patterns was not a Mamluke invention but was used throughout western Asia. Although generally associated with

wakkil's army. This form of decoration was purely abstract and covered the entire surface leaving no space between the component forms. Because it was created by pressing carved wooden moulds with smooth concave patterns on to wet stucco it has a strange bevelled appearance, quite unlike anything previously seen in the Middle East. This particular form of decoration continued for several centuries. It occurs in the Mosque of Ibn Tulun in Cairo, completed in 879, and in 12th- and 13th-century Iran where it was carried out by the Seljuk Turks. Even in the subsequent Mongol Ilkhanid period some-

59 Façade of the Mushattah palace, Jordan. First half of the
8th century. Museum für Islamisches Kunst, Berlin. One of the
most important examples of early Islamic stone-carving.
Naturalistic ornament such as this was taken over from late
Classical art by the Umayyads of Syria. It is an interesting
early example of the combination of foliate and geometric
elements which became the basis of later non-representational
decoration.

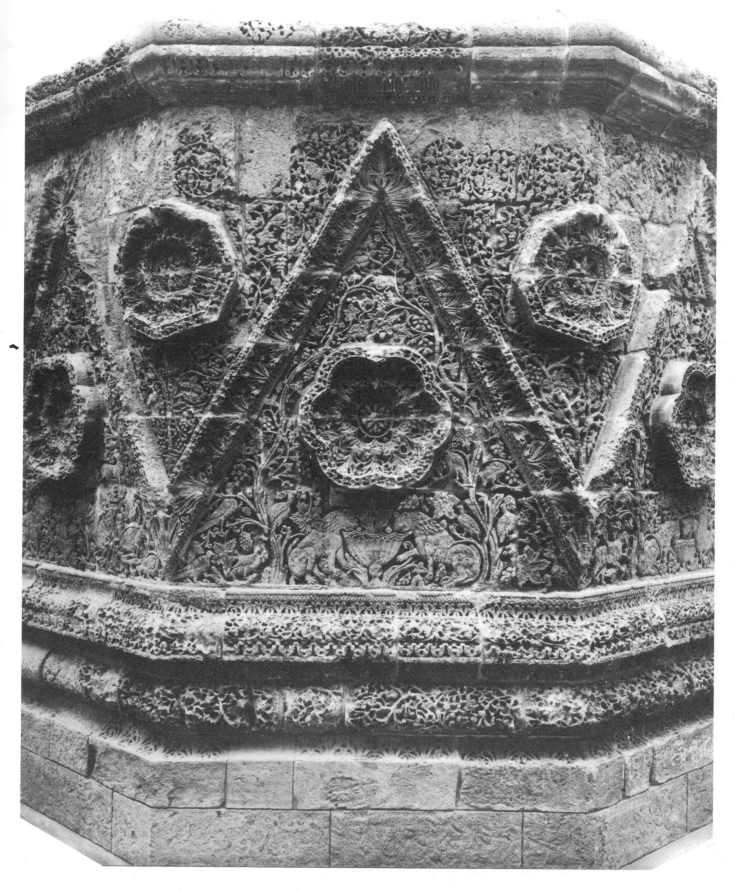

60 Detail from the Ardabil Mosque carpet, Tabriz, Iran. Dated and signed 1539–1540. 36 ft 6 in × 17 ft 6 in. Victoria and Albert Museum, London. The carpet comes from one of the most important periods of carpet production in Iran, and illustrates one of the major principles of Islamic design: the system of multiple levels. By superimposing series of slender foliate arabesques on top of one another a pattern of infinite complexity is created. In mosque carpets this pattern may be a mirror image of that used in the decoration of the walls and dome of the building.

61 Detail from an Almohade battle banner, Islamic Spain or Morocco, 12th–13th century. Convent of Las Huelgas, Burgos, Spain. The basic design, a circle attached to a square, is closely related to contemporary koran frontispieces from Spain and North Africa. The eight-pointed star in the centre is a magic or astral symbol known throughout the Near East, and which here probably reinforces the official Islamic invocations of victory and protection, written in a curious form of Thuluth.

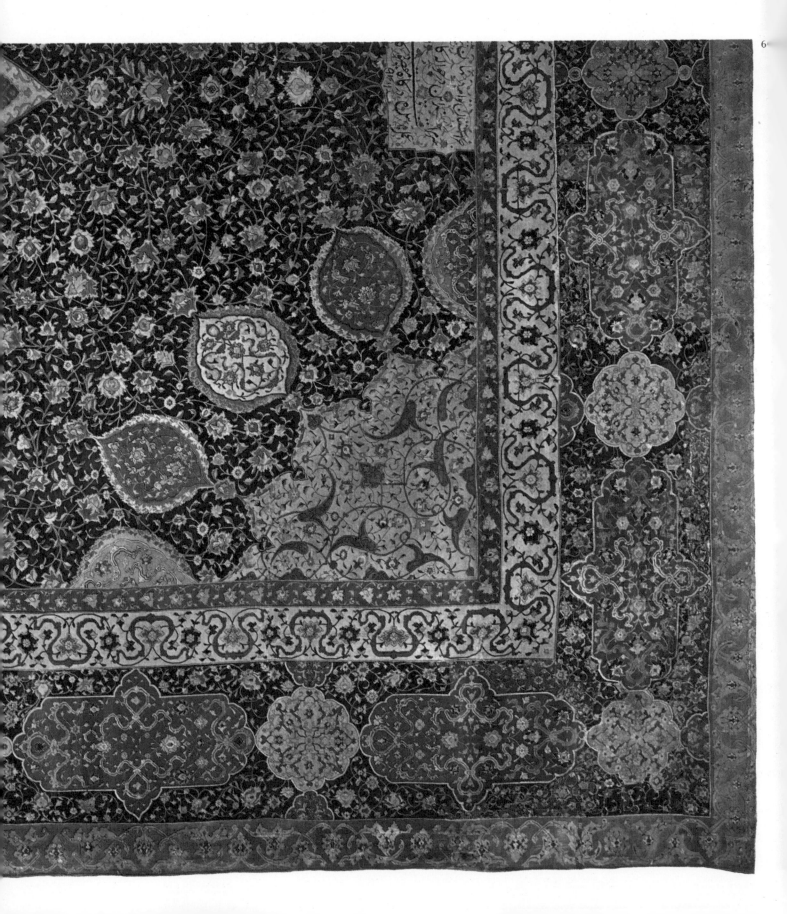

62 Kaftan of Sultan Bayazid II (1481–1512), Turkey. Topkapi Saray Museum, Istanbul. The decoration of this fine robe is typical of 16th-century Ottoman work. Naturalistic flowers and plants predominate and only rarely do animal or human figures intrude.

63 Turkish carpet, about 1600. 10 ft × 4 ft 3 in. Ex Collection of Joseph V. McMullan, Metropolitan Museum of Art, New York. In contrast to the floral carpets of Iran early Turkish carpets and rugs tend to be abstract. Although floral elements were introduced due to the influence of Safavid carpet design, the pictorial imagery of 16th-century Persian carpets never occurs in Turkey. The polygonal shapes and long bands of geometric interlace are reminiscent of Seljuk architectural design in brick and stone.

62

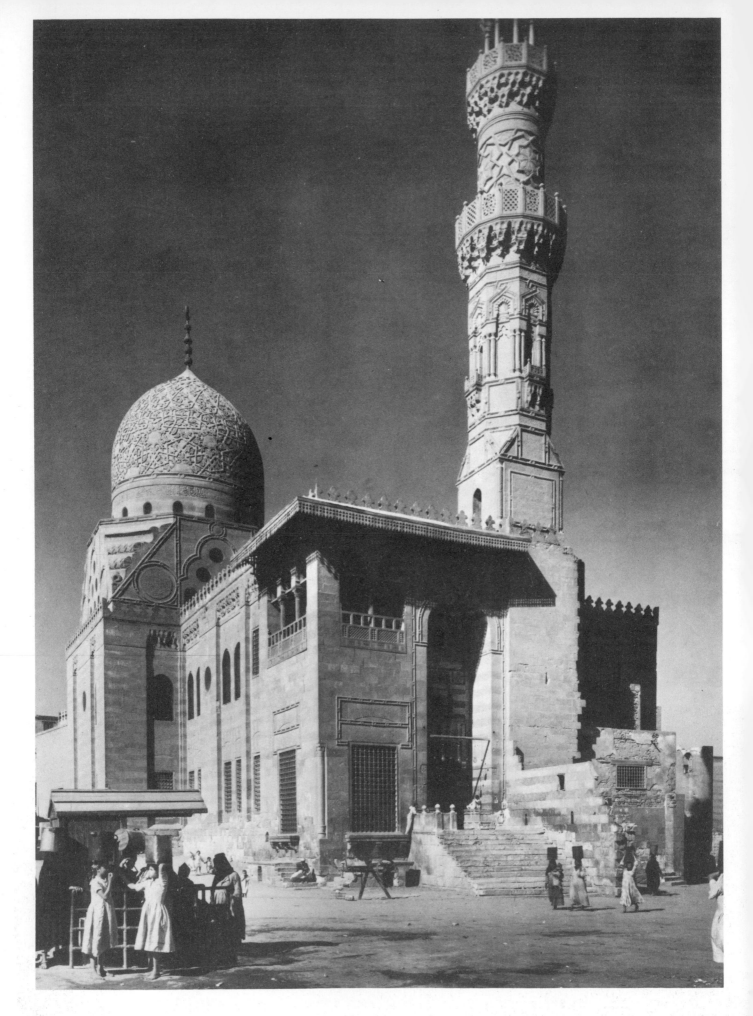

64

64 Madrasah and Mausoleum of Qayt Bay (1468–1496), Cairo. The foliate-geometric complex covering the dome is one of the most characteristic forms of Islamic decoration; here the foliate arabesque is not made up of self-contained units inside the linear pattern but has a separate existence of its own. The bold design on the façade (just visible on the left) appears in various forms in Mamluke decoration. Usually based on linking circular shapes, it originated in the late Classical art of the Mediterranean area.

the great court and mosque carpets of 16th-century Safavid Iran, it also appears on earlier Persian metalwork and koran decoration. And of course, throughout the Islamic Near East, it had long been the practice to superimpose calligraphy and figures over floral arabesque backgrounds.

Seljuk geometric decoration, like that of the Mamlukes, displays a preference for star shapes which often appear as flowers, rosettes or sunbursts. However, Seljuk patterns were often simpler, in the sense that they were made up of regular geometric shapes like octagons and hexagons, which were interwoven in countless different ways. The earliest geometric decoration appears in brick, as shown in the two recently discovered 11th-century Kharraqan tomb towers, and this was translated into other media like tile faience and eventually stone in Anatolia so that the same forms survive intact for several centuries. The occurrence of some of these forms is so persistent that they probably relate to the pre-Islamic beliefs of the Seljuk Turks.

The finest examples of Seljuk non-representational ornament come from the stone-built monuments of the Seljuks of Anatolia. Although there was a certain amount of influence from the long-established stone-carving tradition of the area, the ancient Seljuk motifs endure with remarkable tenacity. Foliate patterns occur as regularly as geometric ones, though there is a tendency to separate the two, unlike woodcarving where both types intermingle in Fatimid and Mamluke fashion. The Seljuk stone masons of Anatolia introduced motifs unknown elsewhere in the Islamic world, like the enlivening of blank surfaces with elaborately carved geometric or floral circular bosses, perhaps inspired by the sight of hardy perennials growing on barren ground.

While the Abbasids, Fatimids and Seljuks were developing new forms of abstract decoration, the craftsmen and artists of Islamic Spain remained firmly attached to the older decorative tradition of Umayyad Syria, from which most of the Arab settlers had originated. The decoration found in the ruins of the caliphal summer palace of Abdal-Rahman III (912–961), Medina Azahra, near Cordoba, although stylised can be linked to earlier Syrian work, such as the carved façade of the Mushattah palace. This decoration was carried a stage further in the carved decoration of the mihrab and western doors of the Great Mosque of Cordoba,

executed by craftsmen from Medina Azahra at the orders of Abdal-Rahman's successor Al-Hakam II. Decoration in both places was carried out on slabs of stone or marble, and consisted of thistle-like plants growing straight up the centre of the slab with equidistant foliage curling in identical patterns to fill the entire space on each side of the stem. Although the conception of these forms is stylised the treatment of them is not, so that they retain a recognisable character, unlike eastern developments of this type of decoration.

In Al-Hakam's additions to the Great Mosque of Cordoba, plaster decoration appears for the first time; prior to this only marble and stone had been used. In later times plaster became the basic material of architectural decoration, the finest of which is to be found in Jewish and Christian buildings; this is the so-called Mudejar art, executed by Moorish craftsmen who were allowed to remain in the reconquered areas of Christian Spain. Some of the best Mudejar plasterwork exists in the old synagogue of El Transito in Toledo built in 1365. Here the individual leaf forms are no longer defined and there are quite new elements, both architectural and geometric.

The finest plaster decoration however is unquestionably that of the Alhambra (14th century) where a breathtaking range of architectural, floral and geometric plaster forms occur in the company of calligraphic inscriptions and tilework. It is the decorative plasterwork which gives the Alhambra an almost fragile appearance and makes us marvel that it should have survived for six hundred years. It was certainly never intended to: palaces were built to last for the lifetime of the ruler. Only a series of happy accidents has preserved the Alhambra while every other medieval Muslim palace has disappeared. The fragile nature of this plasterwork illustrates another aspect of Islamic non-representational decoration, which some scholars believe to be intrinsic. It is suggested that the way in which plaster and tilework cause surfaces to 'dissolve' is done quite deliberately to reflect the transient, temporary character of all earthly structures, and imply thereby the impermanence of human existence.

The technical developments in the field of tile faience mosaic, which allowed coloured inscriptions in the mosque, were also responsible for the polychromatic transformation of the arabesque. This

occurred as early as the first half of the 14th century in the Masjid-i Jami' of Kirman, but was brought to **6** perfection under the Timurids and Safavids in the 15th and 16th centuries when geometric and floral patterns, often the latter alone, executed in tile faience, were laid one above the other to create a series of levels. Multiple level floral arabesques **60** provide complexity without the confusion of simple repetition at a single level. Like the geometric arabesque they provide a web of contemplative complexity, while their formal and colour associations suggest a whole series of possible reactions. The basic blue and green symbolise water and cultivation, the essentials of civilisation in an arid land; they are the colours of the oasis, goal of the weary traveller. Flowers mean spring and the re-awakening of life, evoking Koranic descriptions of Paradise, the goal of existence. Vines, flowers and foliage descending from the sky, as in the interior of a dome, recall the Tree of Bliss, often represented in prayer **76** books in diagrammatic form, planted by the Prophet in Paradise and growing downwards through the eight heavens. The association of floral arabesque patterns with Paradise and the Tree of Bliss also explains their inclusion in Persian mosque carpets and individual prayer mats.

Although the Ottoman Turks continued to use some of the ancient Turkish geometrical motifs, such as patterns made from octagons and hexagons, down to the 16th century, the huge expanses of geometrical carving and tilework so characteristic of 13th-century Anatolian Seljuk art began to die out after 1300. In Ottoman times geometric motifs were almost entirely superseded by floral ones, which however were quite different from the traditional foliate scrolls of Seljuk art. Beginning with the Green Mosque and Mausoleum of Bursa (1421–1424) there arose a new naturalistic floral style which, aided by the development of polychromatic techniques in ceramic production, gave 16th-century Ottoman tiled interiors an appearance quite **96** distinct from those in the rest of the Islamic world. By the second half of the 16th century, interiors were being decorated with tiles painted in seven different colours using an underglaze technique and showing tulips, carnations, hyacinths, peonies and various species of tree blossom rendered entirely naturalistically. In the same period, hexagonal tiles with self-contained designs began to go out of fashion and new types of tile decoration appeared.

66 Pir-i Bakran, Linjan, Iran, 1299–1312. A madrasah which became a mausoleum and interesting for its varied plaster decoration. The central section of this niche recalls the Abbasid ornament of Samarra. On the right is part of a Kufic square. Entire chapters of the Koran were written in this rigidly geometric form of Kufic.

67 Koran, Iran, 1548. 14 × 9¼ in. Chester Beatty Library, Dublin. Right half of a double frontispiece. Safavid koran frontispieces continue the tradition of the previous century, though new elements are introduced and the details are bolder. Here the frontispiece is combined with the opening chapters of the Koran. The script is Naskh. Although Nasta'liq was used for literary works Naskh and Thuluth were retained for the Koran.

Large patterns, sometimes whole plants like plum trees in blossom, were extended over several tile squares forming an oblong panel and often combined with solid rectangular panels, perhaps several feet high, covered with flower designs. Plant forms, even though quite natural in appearance (though not necessarily in colour), were certainly part of a widely understood religious symbolism. Pictures of the rose for example appear in Turkish prayer books, where the stamen is identified with God, the petals with the Prophet, and the lower leaves with his companions. On most occasions when a particular form of non-figural art is employed in mosque decoration and the applied arts, its secular form is often combined with figures. In Ottoman times however this is rare: the naturalistic plant forms of mosque decoration appear to suffice in most other fields. This phenomenon was also true of North Africa where the unity of decoration has other parallels, notably the use of a uniform script, true to a lesser extent of Ottoman Turkey but where, nevertheless, a fine Naskh script was used for both Koranic and literary-historical texts.

Manuscript illumination

By medieval European standards literacy in the Islamic world was widespread. Learning, though often confined to religious studies, was actively encouraged and the rate of book production was enormous. Many books were quite simple in form,

copied by a scholar for his own use and then bound in utilitarian fashion. However if books were written for a royal library or a wealthy patron they were raised to the level of works of art.

Of all books, the Koran was the most important. Although the sacred text was first written without embellishment of any kind, during the two centuries following the Prophet's death illuminated chapter headings and certain kinds of liturgical marginal ornament were added. Artistically, the most important form of Koran illumination was the double (although sometimes single) frontispiece.

The koranic frontispiece was one of the most consistent forms of Islamic art and once established (about the 9th century) changed only very slowly. Its broad line of development was as follows. The earliest type (8th century) consists of a geometric shape, or series of shapes, often with plaited or knotted elements, within a larger square or rectangle to which is attached, on the right or left, a circular leaf-like device made up of foliage. Although this particular combination of geometric and vegetable forms would appear to have been a Muslim invention, the elements which go into its creation all originate in the pre-Islamic Sasanian and Hellenistic art of the Near East.

Although new forms of frontispiece illumination arose in the 10th century, Islamic Spain and North Africa continued to preserve the older tradition. Some developments did of course occur – colour was

70 Detail of interlace on a koran frontispiece, Valencia, Islamic Spain, 1182. A fine example of geometric interlace made up of the word Allah repeated eight times. Although based on archaic models the frontispieces of Islamic Spain and North Africa are among the most interesting of the Islamic world. They may have some connection with cosmological diagrams based on concentric circles. (After Ettinghausen.)

71 Mudejar plaster decoration, Synagogue of El Transito, Toledo, Spain. 1365. Until the end of the Christian Reconquest in 1492 many of the finest craftsmen continued to be of Muslim origin. The foliate decoration here is quite different from that of 10th-century Islamic Spain. The geometric arabesque patterns were introduced to Spain from the east where they had been in use for several centuries.

introduced, the geometric centre became a circle of white interlace occasionally made up of words or pseudo-inscriptions – but the basic format remained virtually unchanged.

A frontispiece with a vertical axis appeared in the east in the 10th to 11th centuries, quite different from the previous horizontal format and the square one of Islamic Spain and North Africa. Among the earliest examples is that of the Ibn Al-Bawwab koran from 11th-century Baghdad. Here we have not only the introduction of colour, but also the appearance of infinitely repeating pattern. Infinite pattern was used by both Seljuks and Mamlukes, often in the star-polygon form found in woodwork and architectural decoration. Appropriate Koranic verses also came to be included, for example, 'Verily it is a glorious koran, inscribed in a hidden book' (ch. 56 vs. 76–77). Perhaps the addition of calli-

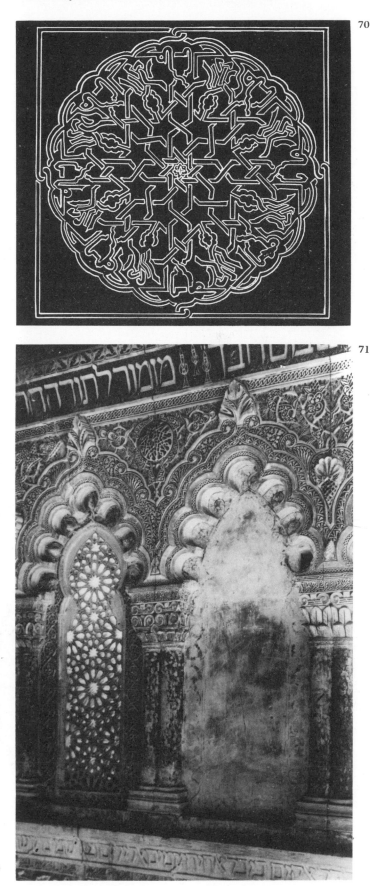

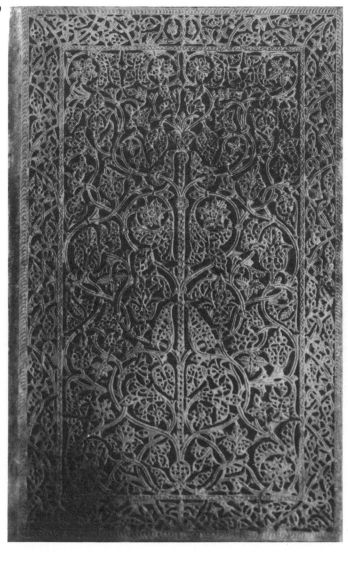

graphic inscriptions gave rise to the final development, the incorporation of the opening pages of the Koran into the frontispiece which is so typical of Timurid and Safavid work.

Timurid and Safavid illumination is quite different from that of earlier times: the background is deep blue and overlaid with golden cloud scrolls and delicately painted foliation, also in gold but with naturalistically drawn flowers in red and white. The effect is one of overwhelming magnificence.

The decline of the abstract frontispiece in Timurid and Safavid Iran is to some extent compensated for by the roundel or rosette which precedes the now sumptuously decorated opening pages. In Persian manuscripts the roundel occurs as early as Mongol times, if not before, and may have originally been a bookplate containing the owner's name. But, in both korans and secular works, it often became a quite separate device, sometimes with religious verse in the centre, at others with a purely abstract composition.

The abstract koran frontispiece was undoubtedly inspired by the illustrated and illuminated frontispieces found in the books of other religions, notably those of the Christians, and while it is possible to look on them as displays of painterly virtuosity their interpretation is probably more complex. Attempts to create a perfect symmetry are an expres-

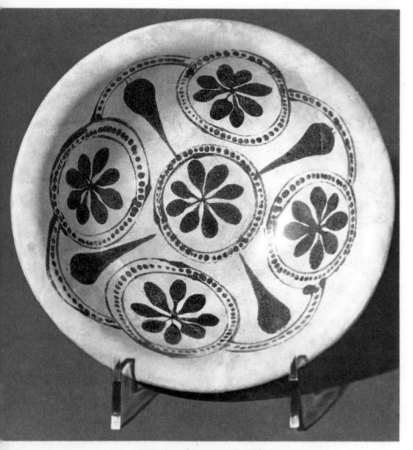

72

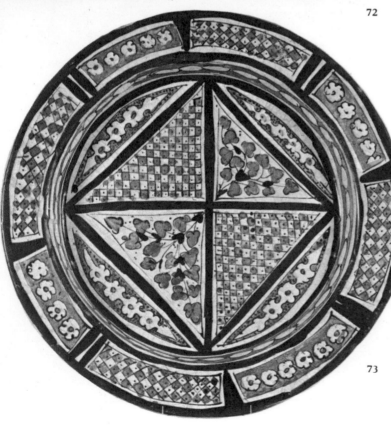

73

74

74 Ceramic plate, Isnik, Turkey, late 15th century. Diameter 17 in. Topkapi Saray Museum, Istanbul. This plate is a mixture of Chinese and Islamic elements: the oval motif and scalloped edge are derived from Chinese blue-and-white porcelain, while the foliate arabesque is Islamic. From the 9th century China exerted the strongest foreign influence on Islamic pottery.

75 Roundel from the beginning of the *Tarikh* (Annals) of Tabari, Herat, 1469. Diameter 3¾ in. Chester Beatty Library, Dublin. The delicate naturalistic detail is typical of Timurid painting and non-representational art. Roundels similar to this occur in Persian korans and manuscripts from Ilkhanid times, sometimes as a bookplate bearing the owner's name but often as pure painting.

76 Pages from a Turkish prayer book, 18th century. $6\frac{3}{4} \times 4\frac{1}{4}$ in. Chester Beatty Library, Dublin. While the Koran was always unillustrated, prayer books often included paintings and diagrams of a symbolic character. On the left is the Prophet's Rose Tree, each part of which is given a special attribution: the stamen is identified with God, the petals with the Prophet, the leaves with the Orthodox Caliphs and Muhammad's companions. On the left is the Tree of Bliss which was planted by the Prophet in Paradise and grew towards the earth from the eight heavens. The specifically religious character of this floral imagery helps to explain its prominence in Islamic decoration.

sion of the idea of a divinely ordered universe, a belief which may also explain why maps of the world and even representations of the Muslim holy places were drawn in terms of geometric regularity. Circular frontispieces, like those from Spain and North Africa where bands of complex interlace converge from the perimeter on a central stamen, may well be related to medieval cosmological diagrams in which the hierarchic structure of the universe was indicated by a series of concentric circles, a symbolic representation known to both East and West in the Middle Ages and traceable back to the ancient philosophers.

Ceramics

Because the basic function of the pot is that of a food container, it is automatically associated with sustenance and human survival, and it is therefore natural that these vital aspects of its nature should be reflected in its decoration. Thus the decoration on the most ancient Near Eastern pottery can be explained in propitiatory and prophylactic terms: to ensure good harvests, rain, an ever-increasing herd or flock etc., and to prevent the opposite, by the use of symbols understood by the gods.

An intuitive belief in the efficacy of particular forms of decoration as protection or wish-fulfilment may well explain the appearance of certain animals, or combinations of animals, and symbols on Islamic pottery. The Abbasid pottery of 9th- and 10th-century Mesopotamia is particularly rich in non-figurative decoration, some of which is certainly of prehistoric Mesopotamian and Near Eastern origin. An interesting example is the large polychrome lustre plate in the Victoria and Albert Museum. Studies of ancient Persian pottery have suggested that the quartered square, the checkered design, and probably the trees or plants growing from the

77 Koran frontispiece, 9th–10th centuries. $13 \times 9\frac{3}{4}$ in. Chester Beatty Library, Dublin. Early frontispiece containing floral, geometric and interlace elements, the basis of later Islamic design. The central motif of four circles around a larger one is found throughout the Mediterranean area in Islamic times, and is perhaps inspired by late Classical decoration though its ultimate origin is much earlier. The large leaf device on the left, whose precise meaning is uncertain, is derived from the art of Sasanian Iran. Once composed these designs endured for centuries: the layout of this frontispiece is almost identical to that of the 15th-century Mamluke frontispiece on page 25. The design is painted in gold on parchment.

central intersection all have lunar associations, the quarters representing the four quarters of the moon which was a powerful water symbol. Similarly, because in Islamic art the quantity of things depicted was rarely accidental (to the extent that one art historian refers to an 'aesthetic of numbers'), the division of the rim into eight segments is not without importance. Eight-sided figures presumably had some astral reference, that is the seven heavenly bodies and the region of the Fixed Stars. For the Muslim potter of course the significance of the lunar symbol may have been lost; he probably considered it a simple good luck sign.

At the same time our plate has numerous specifically Islamic references, the most important being the use of lustre. Lustre was one of the Islamic potter's most important discoveries. Invented in Egypt shortly after the Muslim conquest, it was imported to Abbasid Iraq in the 8th century and used both there and in Iran in Seljuk times (12th and 13th centuries), and under the Safavids (17th century). It was also employed in the decoration of Egyptian Fatimid pottery (11th and 12th centuries) and in that of Muslim Spain, making it a truly 'international' element of Islamic pottery.

This and other international elements predominate in the decoration of a large ceramic vase from 5 13th-century Damascus: calligraphy, interlace, foliate arabesques and the blue-and-gold colour combination are basic ingredients of Islamic design, though their employment here is quite original.

At other times peculiarly local forms could almost totally overwhelm the decoration of pottery, the naturalistic flora of Isnik ware for example, or the figure painting of Persian Seljuk work.

Because Chinese ceramics were universally admired throughout the Near East to which they had been exported since early Islamic times, Muslim potters strove repeatedly, presumably at the request of patrons, to imitate some of its qualities. However, it has been pointed out that this was not a continual aspiration towards a single goal, but sporadic imitation of certain aspects. In 9th-century Mesopotamia T'ang glazes were copied, then under the Seljuks attempts were made to reproduce fine hard porcelain resulting in the superb Seljuk white ware of 12th-century Iran. On later occasions only decoration was copied; sometimes the entire design and colour (to the extent that Persian 17th-century 74 blue-and-white ware was exported to Europe by the Dutch as Chinese), at other times only a small portion of a design may be of Far Eastern inspiration.

From our references to Islamic pottery, in this and other chapters, it should be apparent that the subject is one of immense complexity. While we can judge a piece of Islamic pottery using the same simple criteria that we would apply to any work of art, assessing whether its shape, colour and design

78 Portal ivan of the Masjid-i Jami', Kirman, Iran, 1349. An early example of the polychrome tile faience technique of decoration.

79 Prayer hall of the Mosque of Alaeddin Kayqubad, Konya, Turkey, completed 1220. Seljuk mosques in Anatolia were usually covered because of the climate, and consisted of a long hall ending in one or more domes along the mihrab wall. The rugs are modern.

80 Ceramic bowl, Valencia, Spain, about 1400. Diameter 18 in. Hispanic Society of America, New York. One of the most magnificent of a series of lustre plates and bowls made by Mudejar craftsmen in Valencia. Although Valencia had been in Christian hands since 1238 potters continued to work in an Islamic tradition. The decoration contains international Islamic elements as well as others of peculiarly local Iberian significance, and has both religious and magical aspects, all of which make it an object of great cultural complexity.

appeal to us or not, obviously for its maker and owner those aspects would have aroused feelings and evoked memories quite different from our own.

In conclusion we might take a piece of pottery such as the fine lustre-painted bowl from 15th-century Valencia, and point out some of the references within its decorative scheme that make it not only an object of great beauty but a complex cultural document with numerous levels of meaning— religious, magical, Iberian and Islamic.

Gold, blue and white are the basis of the international Islamic colour repertoire. At the same time the brownish-gold used here, along with blue and white, are the predominant colours of the Andalusian landscape, where this design originated. The proto-design was probably Mesopotamian, from where pottery had been imported since early Islamic times (a very similar design, a lobed octagon with four pronounced horizontals radiating from an eight-leaved rosette, appears on a 9th-century bowl from Iraq). The entire Valencian decorative scheme is based on the number eight, a figure with powerful cosmological and magical connotations, though the central motif has specifically Iberian Muslim connections: it occurs on the flag of the Almohades and is an almost exact copy of the vaulting system of the mihrab chapel of the Mosque of Cordoba. The two superimposed squares surrounded by trees and foliage can be taken as a general allusion to Paradise and a reference to the pool and garden patio at the centre of any Muslim building complex. The zigzag decoration could be a contemporary Gothic heraldic device or an ancient water symbol; whatever its intent the device has existed in the Iberian peninsula from megalithic times, appearing on eye-idols found in Estremadura.

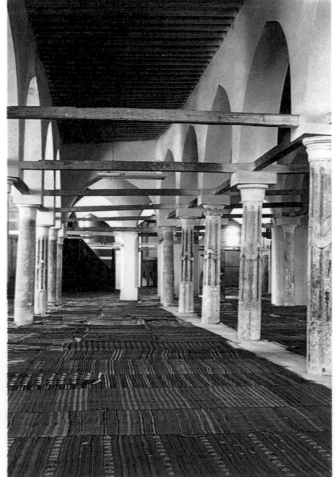

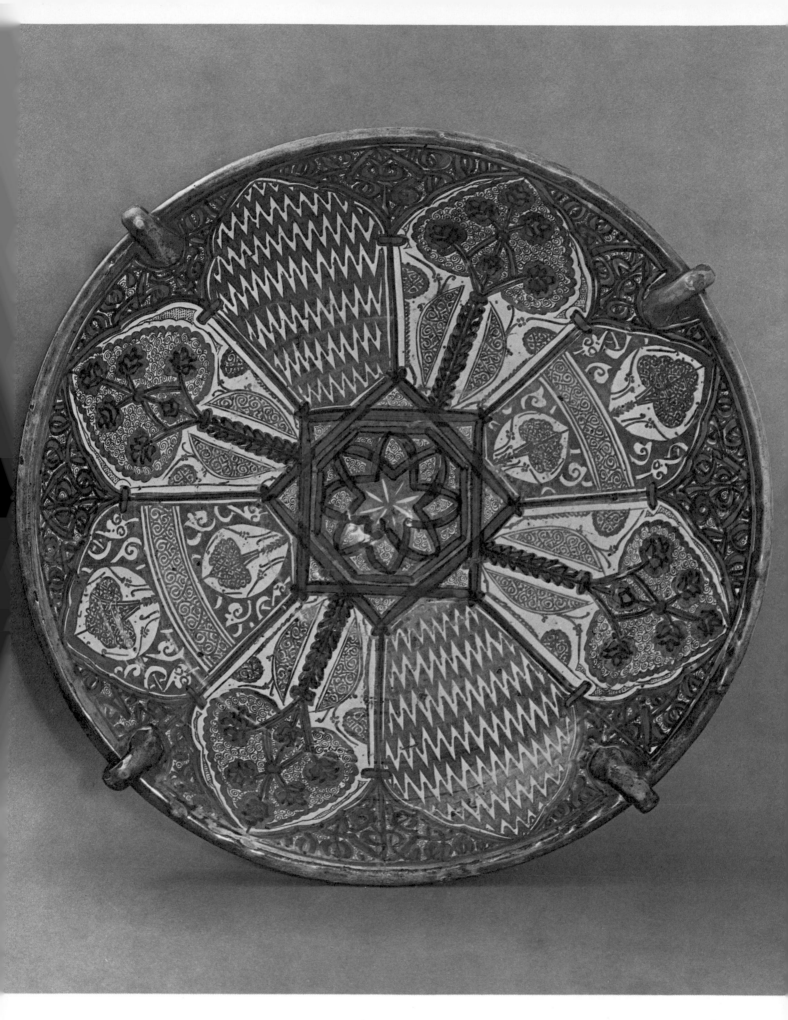

Architecture

Islamic architecture revolves around two very different structures, the mosque and the palace. The mosque is unusual in religious building in that it has no liturgical centre, the mihrab simply indicating the direction of Mecca. Most mosques create a feeling of balanced equilibrium by avoiding concentration on any fixed point or direction. Even when the concept of verticality is employed this is generally counteracted by expansion in a lateral direction. The palace on the other hand is dominated by the personality of the monarch whose audience chamber forms an obvious focal point of the building complex.

Because of the social and political basis of Islam the mosque has rarely been simply a place of worship; it corresponds to church, townhall, school and hostel, all under one roof. Artistically the mosque is of great importance. Not only did the finest calligraphers and decorators embellish its surfaces and mihrab, but all objects of furniture in wood and glass (lamps, minbar or pulpit) etc. were of the highest quality. There were three types of mosque: the open-plan, four-ivan, and domed mosque.

The open-plan mosque

At its simplest the mosque was a rectangular area covered on the side facing Mecca and the direction of Mecca indicated, first by some mark and later by a niche, the mihrab. This was the earliest form of mosque established by Muhammad in Medina and was favoured, with slight modifications, in the areas of Arab settlement around the Mediterranean.

The Great Mosque of Damascus (Umayyad, 705–715) Although built within the area of a Roman temple, the Great Mosque employs the open plan in a form which became standard throughout the Mediterranean. The large courtyard is surrounded on three sides by roofed arcades (Ar

riwaq); on the fourth is the prayer hall containing the mihrab. The prayer hall is three aisles deep, the aisles running parallel to the mihrab wall. The aisles are cut across by a raised transept surmounted by a dome. The dome is a modern structure, though apparently there was an earlier one for it is mentioned in the 10th century. The mosque had the first minarets in Islam, originally square towers at the corners of the Roman temple which were adopted by the muezzin (Ar.mu'adhdhin) for giving the call to prayer.

The Great Mosque of Qairawan, Tunisia (Abbasid) Most of the present structure dates from the 9th century when the early 7th-century building was replaced. Here there are seventeen aisles at right angles to the mihrab wall but not actually reaching it. The central aisle which runs down to the mihrab is wider and higher than the others and is surmounted by two domes, the earliest one in front of the mihrab and the other at the far end of the aisle near the courtyard. The mosque was built without arcades around the courtyard; these were added later. The massive minaret is the oldest part and stands at the far end of the courtyard not quite in line with the mihrab. The most remarkable part of the building is the mihrab, a concave chapel dating from 862. The interior is faced with marble grills carved with ornament of late Classical (i.e. Hellenistic) derivation and faced with lustre tiles imported from Iraq, the earliest examples of lustre which can be positively dated. Several of the designs resemble the central symbol on the 9th-century lustre dish from Mesopotamia (see page 70).

The Great Mosque of Samarra (Abbasid 848–852) Built at the one-time Abbasid capital it is the largest mosque known. It uses the open plan but with half-towers all the way round the outside

81 Courtyard of the Masjid-i Jami', Isfahan, Iran. The mosque
is one of the finest examples of the four-ivan court type in
which ivans, or vaulted halls, lead off from each side of the
inner courtyard. The picture shows the north-west ivan. The
mosque was repeatedly added to and illustrates almost a
thousand years of structural development in Persian
architecture.

82 The mihrab chapel, the Great Mosque of Cordoba. The mosque was begun in the 8th century and enlarged several times until the end of the 10th. The most important extension was that begun by the Andalusian caliph Al-Hakam II in 961. The present mihrab and the chapel in front of it date from that time. The work was carried out partly by craftsmen from the royal palace of Medina Azahra, and partly by Byzantine artists who are said to have been responsible for the mosaics.

In general the decoration follows the late Classical-Umayyad style of the eastern Mediterranean. The building has several unique and unusual features, particularly the method of supporting the roof by short columns placed one on top of the other.

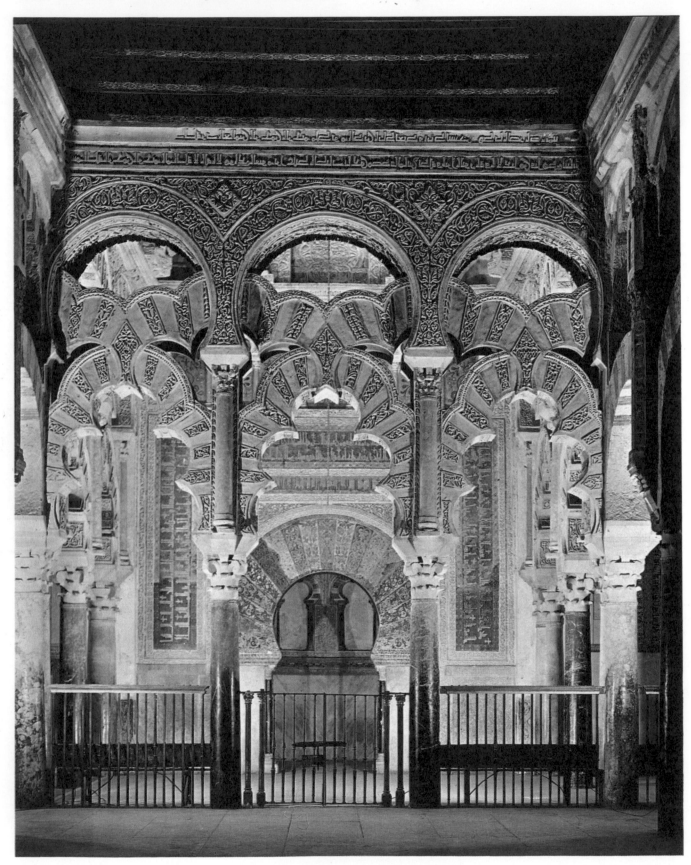

83 The Buland Dwarza (Gate of Victory), Jama Masjid, Fatehpur Sikri, India. The Jama Masjid or Great Mosque is the largest building of the Mughal Emperor Akbar's ceremonial capital Fatehpur Sikri. Begun in 1571 the mosque is a variation of the open-plan Arab type, and is supposed to be based on the Mosque of Mecca. In 1602 the original southern gate was replaced by the enormous Buland Dwarza which dwarfs the entire city. The gate, which is practically a building in itself, is given an even greater appearance of monumentality by being set at the top of a steep flight of stairs and having its sides recede at an angle. As in contemporary painting Hindu and Islamic elements are combined, reflecting the Emperor's bipartisan approach towards the two communities of Mughal India.

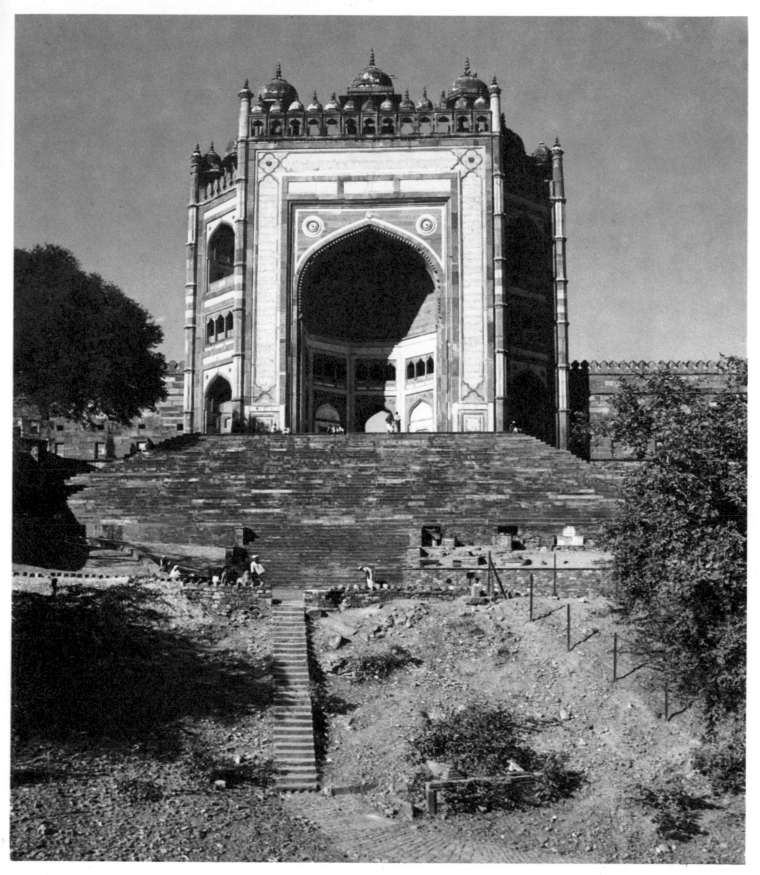

façade. The most famous part of the mosque is the winding minaret some ninety feet high.

The Mosque of Al-Hakim (Fatimid, 990–1013) 84

The mosque follows the design established in Egypt by the Mosque of Ibn Tulun (876–879), which had introduced certain Abbasid features like the huge brick piers round the courtyard and a winding minaret. In the Mosque of Al-Hakim, brick piers are once again employed to support the roofing system of the prayer hall and courtyard arcades. There is a raised transept leading to the mihrab, over which is a dome. At either end of the mihrab wall are two other domes. In line with these, against the façade of the entrance wall, are two minarets. Between the minarets is a fine stone-built portico.

The façade of the mosque is also stone-built and decorated with carved inscriptions and geometric designs. However the finest stone carving of the period is found on the façade of the Mosque of Al-Aqmar, also in Cairo, finished in 1125.

The Mosque of Cordoba (Spanish) 85

This is the most magnificent of all the open-plan mosques. It was begun by Abdal-Rahman I in 785 and continually expanded to accommodate the growing population of Cordoba until the end of the 10th century. The first mosque had eleven aisles at right angles to the mihrab wall, no minaret, and was without arcades around the courtyard. These were added 82 soon afterwards by Abdal-Rahman's successors.

In 833 the mosque was extended towards the south. There was a similar extension in the time of Al-Hakam II when the present mihrab was added (961–965). Finally in 987–988, eight extra aisles were added to the east making a total of nineteen.

The most remarkable aspect of the mosque is the system of two-storey arcades forming the aisles. By placing two columns one on top of the other the roof was given the required height. The device may have been inspired by the Roman aquaducts in Spain, though there is nothing quite like it anywhere.

The four-ivan court mosque

The mosque consisting of an open court with an open vaulted hall in each side developed in Iran under the influence of the huge Sasanian ivan at Ctesiphon which continued to inspire Muslim architects.

84

85

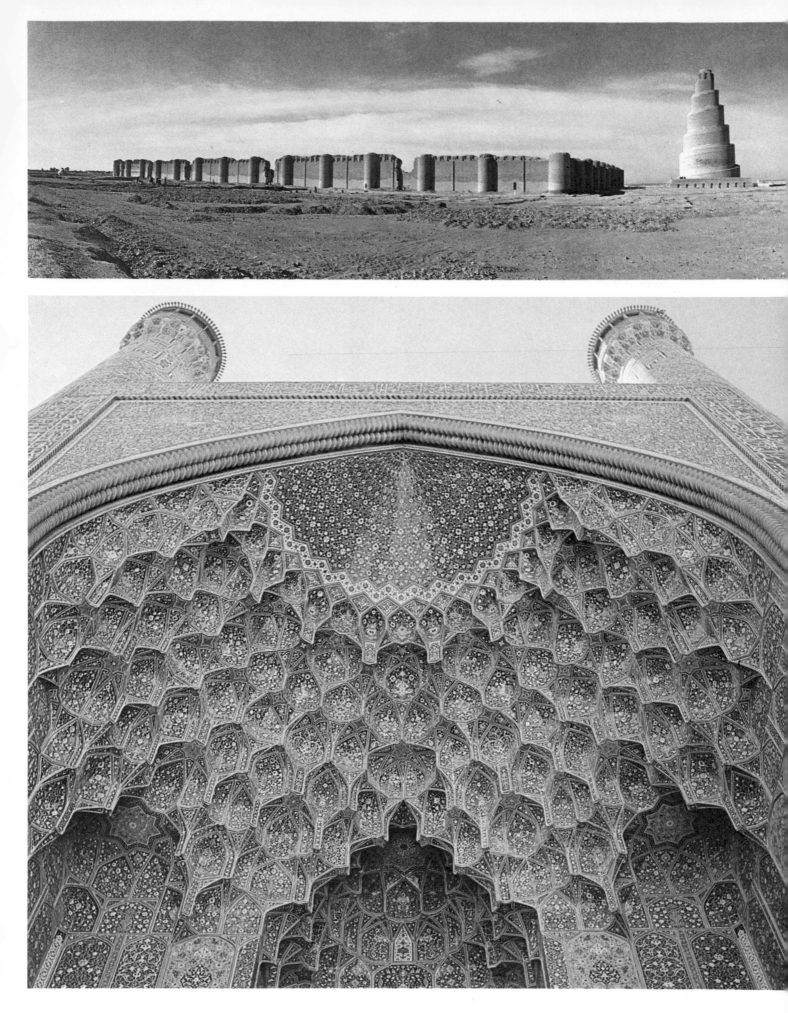

81, 88 The Masjid-i Jami' of Isfahan (Seljuk, 1072–1092) The Masjid-i Jami', or Great Mosque, of Isfahan was built by the Seljuk ruler Malik Shah (1072–1092) and is the most important example of the four-ivan court mosque. There are four ivan halls leading off the open court, one in the centre of each side. Behind the prayer hall ivan is a spacious **89** chamber supporting a huge dome fifty feet in diameter, which rests on trilobed squinches borne by cylindrical piers. Directly opposite at the north end of the mosque is a small dome, the Gunbad-i Kharka (1088) which, although not part of the basic structure of the four-ivan type, is important as both aesthetically and mathematically it is the most perfect dome known. In this dome and the main one in the prayer hall, the transformation from chamber to dome is effected by a system of blind pointed arches running round the interior base of the dome. This became the standard method of transition in the buildings of the period.

Little remains of Ilkhanid mosque architecture and almost the only surviving example, the Masjid-i Jami' of Taj Al-Din Ali Shah at Tabriz (1310–1320), is built in a rather unusual way, lacking the dome chamber and constructed in undecorated brick which gives it an appearance of overpowering monumentality.

More in the tradition of the four-ivan mosque is the Masjid-i Jami' of Kirman, built in 1349 by a local dynasty, the Muzaffarids, whose superb tile faience decoration prefigures later developments in mosque decoration.

The Mosque of Gauhar Shad, Herat (Timurid, 1418) This is the finest, and almost only, Timurid mosque. Built in Herat in 1418, it employs some ideas first used in the buildings erected by Timur at his capital Samarkand some twenty years before— the Royal Palace at Kesh (1390–1405) and the so-called Mosque of Bibi Khanum (begun 1399). The main portal for example is set with an inner arch as in the palace at Kesh, while the flanking minarets stretch right down to the ground.

The Masjid-i Shah, Isfahan, 1612–1638 Although the Safavids were in power for almost a hundred years before the removal of the capital to Isfahan in 1589, almost nothing remains of their early buildings at Tabriz and Qazvin. The Masjid-i Shah, built for Shah Abbas the Great (1587–1629), is the culmination of a tradition which had previously reached its highpoint in the Masjid-i Jami' of Isfahan. The building is entered through a recessed portal flanked by two minarets, sheathed like the courtyard ivans and sanctuary dome in light blue tile. The portal is set at an angle to the inside court. The court contains a wide ablution pool and around this are set the four ivans in the centre of two-storey symmetrical arcades. The ivan in front of the dome chamber is of great height and framed like the portal with two minarets. The dome is set on a high drum and partly hidden by the ivan.

The domed mosque

Both Iranians and Turks made important contributions in the development of the mosque with a unified central dome. However it is with the latter that the most advanced form is associated. One of the earliest Turkish examples is the Mosque of Talkhatan Baba, near Merv, built at the end of the 11th century. The mosque is rectangular in shape and has a central dome extended on each side by cross vaults. This was one of the first steps towards the great Ottoman mosques of the 16th century.

89 Dome of Malik Shah, Masjid-i Jami', Isfahan, Iran, 1080. The mosque is one of the earliest and most important examples of Seljuk religious architecture. The enormous dome, some fifty feet in diameter, was erected over the mihrab chamber at the command of the Seljuk ruler Malik Shah (1072–1092). The transition from square chamber to dome can clearly be seen in the simple exterior of undecorated brick.

90 The palace of Ukhaydir, Iraq, late 8th century. Built of rough slab masonry Ukhaydir is the only Abbasid palace complex to have survived virtually intact. The palace proper is surrounded by a heavily fortified wall with four gates, though the main part of the complex can only be entered through one entrance. The ground plan resembles the central part of the Mushattah.

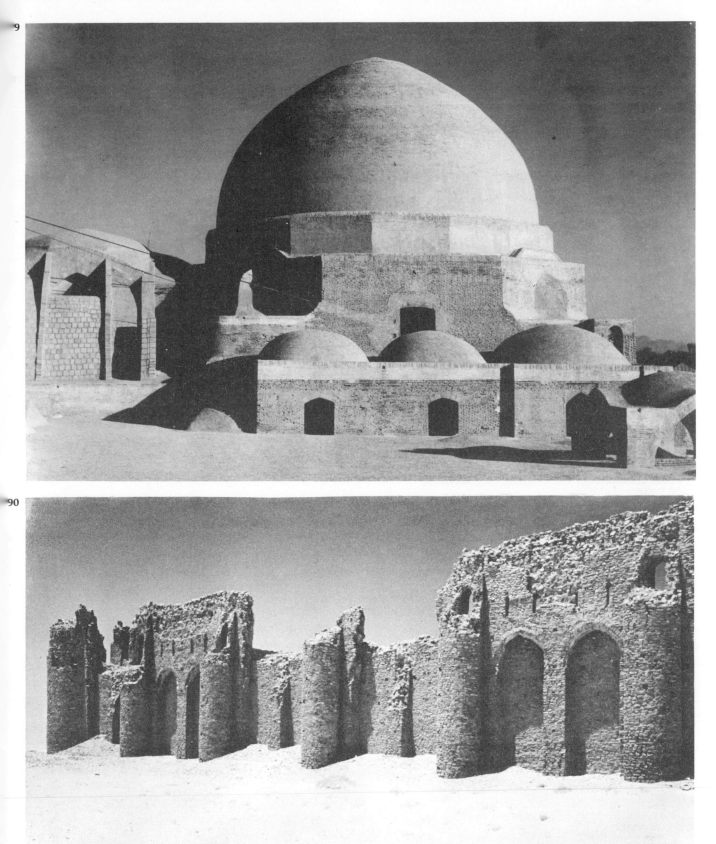

91 Audience chamber, Medina Azahra, 10th century. The legendary palace of the caliphs of Cordoba begun by Abdal-Rahman III in 936 and destroyed in 1010. Parts of the palace are being restored, though what has been completed gives little impression of the breathtaking splendour recorded by medieval chroniclers.

92 Plan of the Selimiye Mosque, Edirne.

93 The Blue Mosque, Tabriz, Iran, 1465. Built by the Qara-Quyunlu Turkomans who occupied western Iran until 1469, this mosque is unusual for the area in that it is a domed structure without the usual four-ivan court. The photograph shows the blue tiled interior from which the building takes its name.

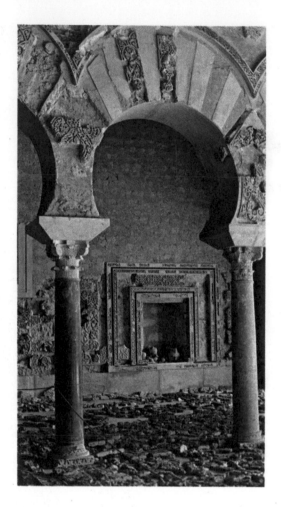

development of the Ottoman mosque with its massive dome.

Ottoman architects found several solutions to the problem of roofing a covered space. In the Ulu Jami' of Bursa (late 14th century) they developed the Seljuk idea of multiple small domes, placing five domes along each of the four aisles. Undoubtedly the real impetus towards creating a structure with a unified central dome came after the conquest of Constantinople in 1453 with the desire to create a building rivalling Aya Sofia.

One of the best attempts prior to the 16th century was the Uch Sherefli Mosque at Edirne (1437–1447), in which the central dome is set on hexagonal piers and six arches and then extended at the sides by four small domes. The Uch Sherefli prepared the way for the great experiments of the following century.

The Selimiye Mosque of Edirne (Ottoman, 1567–1574) The Selimiye was built by the finest of all Turkish architects, Sinan. Its huge dome is larger than that of Aya Sofia and rests on an octagonal structure with eight piers taking the weight. The central dome is extended even further by four half-domes on each side. There is an arcaded courtyard with nineteen domes, similar to the Uch Sherefli; here however the four minarets are placed at the corners of the mosque, and not in the courtyard as in the earlier building. This has the effect of concentrating attention on the dome.

92

The structure of most Seljuk mosques in Anatolia differed from those of Iran, being a long prayer hall culminating in one or more domes on the mihrab wall. One of the earliest examples is the Alaeddin 79 Mosque, Konya, begun in 1156 but with several later additions.

The Mosque of Alaeddin Kayqubad, Nigde (Seljuk, 1223) This is one of the most typical mosques of the period. It survives in its original plan: three aisles end in domes on the mihrab wall. There is no courtyard but the middle of the central aisle is open. The mosque is entered through a monumental portico on the east, stone-built like the rest of the mosque and richly carved. Near the portico on the corner of the mosque is a single minaret.

The Seljuks possessed numerous single-domed structures, masjids (meaning district mosques in Turkey) and madrasahs. While these were modest structures some, like the Karatay Madrasah of 57 Konya (1251), undoubtedly played some part in the

92

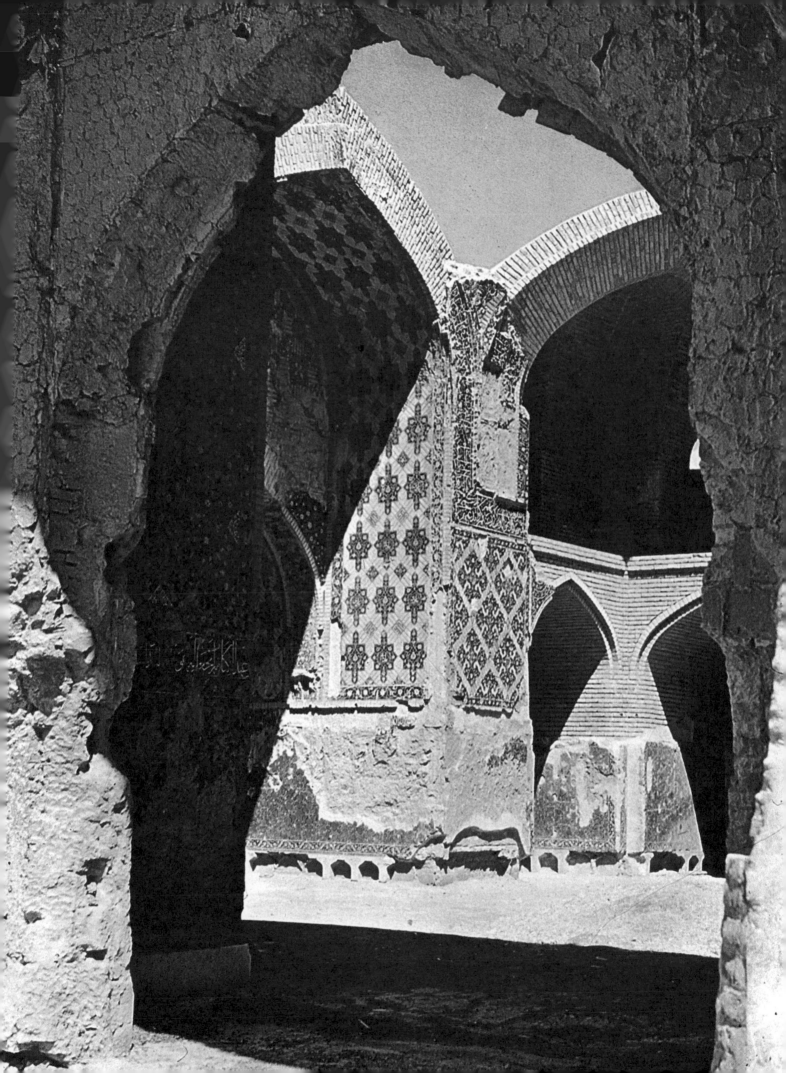

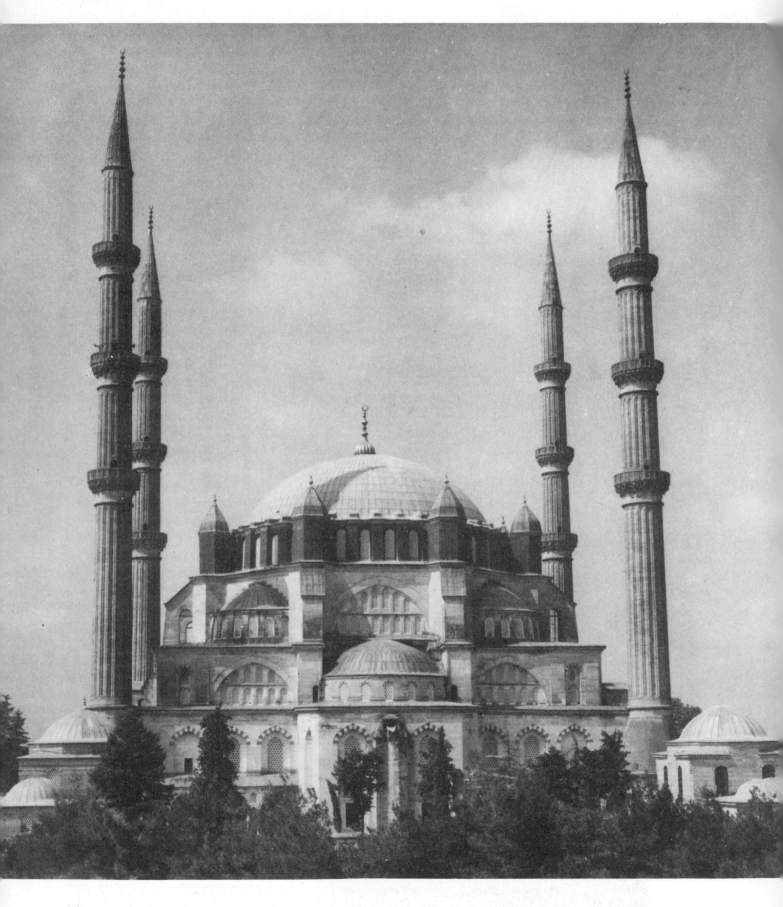

94 The Selimiye Mosque, Edirne, Turkey, 1567–1575. The most perfect example of the Ottoman domed mosque and crowning achievement of the architect Sinan. The mosque is the culmination of a tradition stretching back many centuries, but given particular impetus after the capture of Constantinople by the desire to rival the dome of Aya Sofia, finally achieved here.

**95 Plan of the Alhambra Palace, Granada. (1) Original
entrance; (2) First court; (3) Mosque; (4) Road, (5) Court of
Machuco; (6) Tower of Machuco; (7) Mexuar; (8) Court of the
Cuarto Dorado; (9) Cuarto Dorado; (10) Court of Myrtles, or
Alberca; (11) Chamber of la Barca; (12) Hall of the
Ambassadors; (13) Bath; (14) Court of the Screen; (15)
Quarters of Charles V; (16) Tower of the Queen's Boudoir; (17)
Garden of Daraxa; (18) Mirader of Daraza; (19) Chamber of
the Two Sisters; (20) Court of Lions; (21) Hall of the
Mocárabes; (22) Hall of Justice; (23) Hall of the Abencerages;
(24) Cistern; (25) Ditch; (26) Tomb; (27 and 28) Palace of
Charles V, begun 1526.**

The palace

Palaces were normally rebuilt or replaced by successive monarchs and for that reason very few exist today.

The desert palaces of the Umayyads are some of the earliest surviving Islamic monuments. They appear to have been the centres of country estates rather than hunting lodges as was believed previously. They are similar in form, consisting of a central court of two-storey arcades surrounded by towers, and with a heavily fortified gate which was also the reception hall. These palaces are in fact modifications of the Roman frontier fort.

Among the two most interesting are those of Khirbat Al-Mafjar (724–743) in the Jordan Valley and Al-Mushattah near Amman. The former is best known for its luxurious bath and audience chamber with fine mosaic floor and figure sculpture. The bath is not in the palace proper but is situated in an attached complex. The Mushattah was built after Khirbat Al-Mafjar and is the most ambitious of these early Umayyad structures. There are two courts, one behind the other, and a basilica-type reception hall, probably of Sasanian derivation.

Of the gigantic palaces built by the Abbasids at Samarra only the gate of the Jausaq Al-Khaqani (836) survives. However examination of the site of the palace shows it to have been the most grandiose complex ever created in the Islamic world. Once through the main entrance a succession of rooms and chambers led to a court with a fountain, behind which lay the apartments of the caliph. Beyond was the domed throne room with four halls radiating from it. Finally there was a spacious esplanade with fountains and a canal.

Once abandoned, the unbaked-brick palaces of Samarra rapidly crumbled into dust. Ukhaydir (late 8th century), a fortified palace south-west of Baghdad, was built of stone and like the Umayyad structures has survived to the present day. The palace has an entrance hall, court of honour and audience chamber, rather like the central part of the Mushattah. Unlike the Mushattah there are four other clearly defined smaller courts grouped around the main ones. These are all separate from one another and were perhaps intended for the wives of the prince for whom the palace was built.

In recent years several palaces have been excavated inside Turkey. Perhaps the two most important are the complexes at Diyarbekir and Kuba-

dabad. Both consist of chambers around a central court, though each is different in plan.

Kubadabad, named after the Seljuk Alaeddin Kayqubad, was built in 1236 near Lake Beyshehir. It has a somewhat asymmetrical plan consisting of rooms and chambers to the north of a courtyard. The most prominent part of the palace was the high ivan throne room set almost against the east wall of the palace. Behind these buildings lay a garden stretching down to the lake.

The palace at Diyarbekir was built by a local Turkish dynasty, the Ortukids, in the early 13th century. It is set around a cruciform court with an ornamental waterway leading from the south to a central pool and fountain. In the Ortukid palace glass mosaic was used for the first time in Turkish architecture.

96 Topkapi Saray Palace, Istanbul, Turkey. The palace consists of a number of small palaces and kiosks (pavilions) on a site overlooking the Bosphorus. The photograph shows the tile decoration of the entrance wall to the Circumcision Room (16th century). The room is decorated with tiles from many periods beginning with the early 16th century and continuing through to the 18th. Of particular importance are the large ceramic slabs (lower left) with naturalistic plant forms, a type peculiar to Ottoman Turkey.

97 The Taj Mahal, Agra, India, about 1635. The most grandiose of a series of Islamic mausolea; based on the simple Samanid Tomb of Bukhara but incorporating many later developments, like the open galleries first seen in Ilkhanid architecture. The immediate prototype of the building is the Tomb of Humayun, the second Mughal emperor. Shah Jahan ordered the mausoleum for his wife Mumtaz Mahal and is said to have envisaged an identical one for himself in black marble directly opposite.

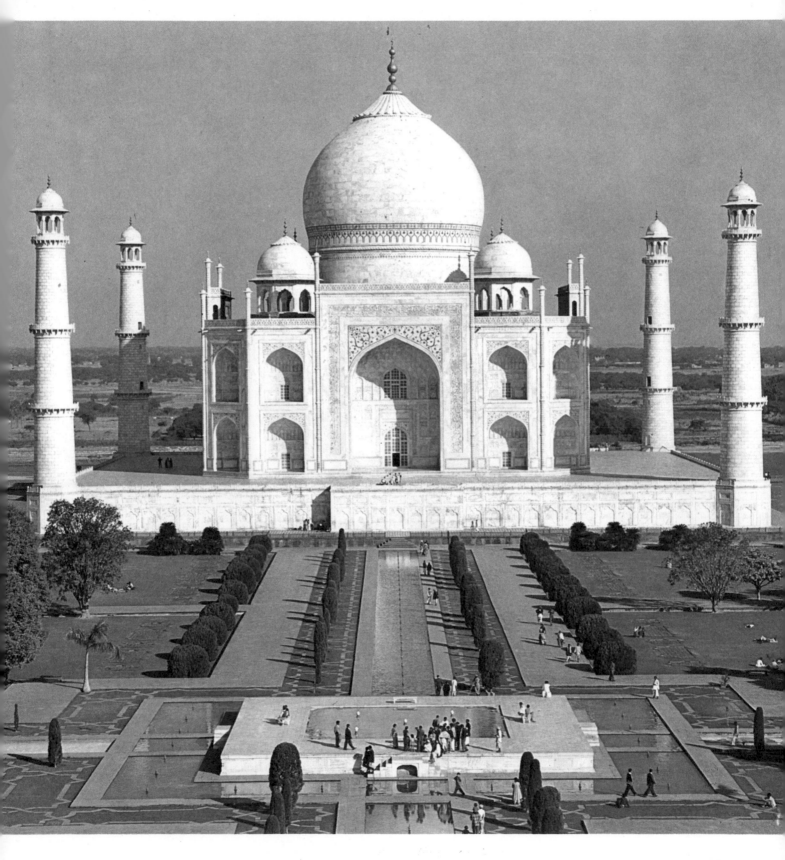

98 The Madrasah-Mausoleum of Sultan Hasan, Cairo, 1356–1363. One of the most impressive of madrasah-mausoleum complexes built by the Mamluke sultans. The madrasah has an open four-ivan court with the domed mausoleum located behind the main ivan. The massive façade is almost devoid of decoration apart from the series of recessed niches running round the mausoleum.

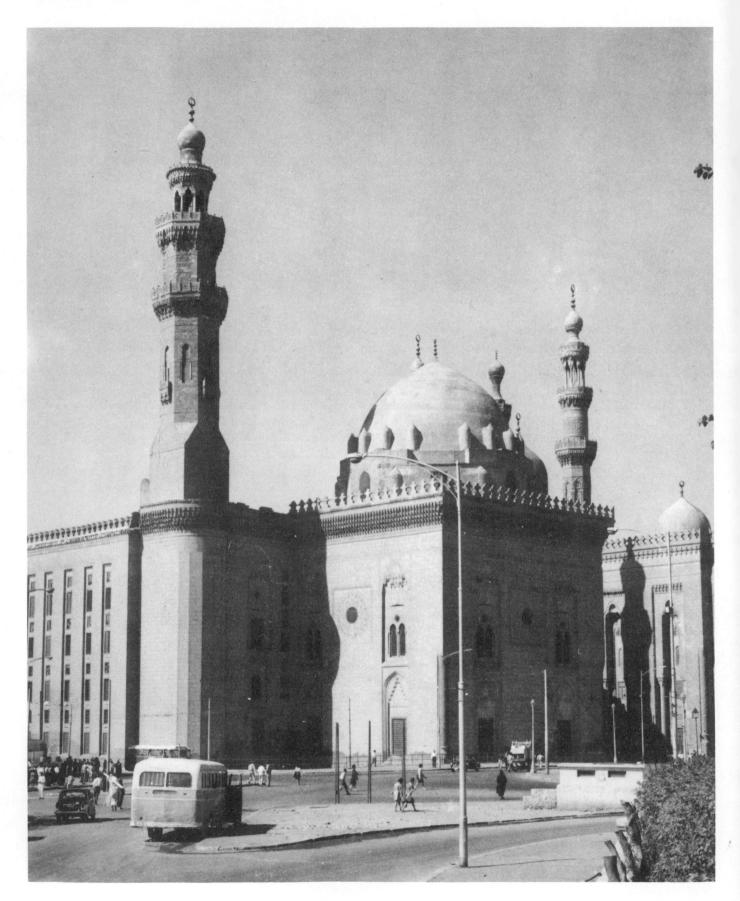

99 The Gunbad-i Qabus, Gurgan, Iran, 1006–1007. Perhaps the most expressive of all Islamic funerary monuments: an undecorated brick tower, some two hundred feet high, culminating in a tent roof. During the next two centuries a similar, though much smaller, type spread across Iran and Anatolia.

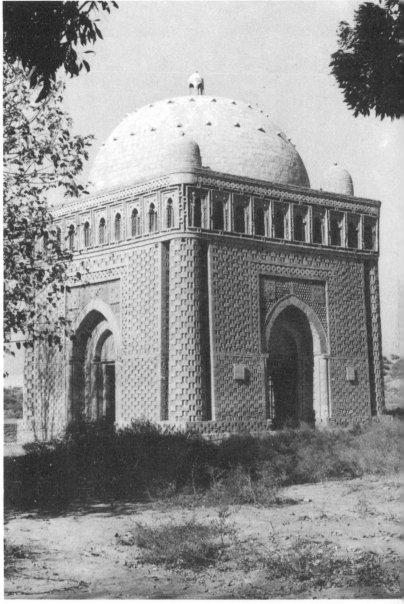

100 Samanid Mausoleum, Bukhara, Central Asia, first half of the 10th century. Although only a small building the tomb exerted an important influence on later structural and decorative developments in Islamic architecture. Some of the greatest buildings of subsequent centuries (the Mausoleum of Oljetu, the Taj Mahal) can be traced back to this modest beginning.

The largest surviving Islamic palace is the sprawl-
96 ing complex of Topkapi Saray. It was begun in the 15th century and added to by successive sultans until the 19th century. It consists, in fact, of a lot of smaller palaces and kiosks (pavilions) set amid gardens overlooking the Bosphorus. The oldest part is the Chinili Kiosk (Tiled Pavilion) built in 1472. In plan this resembles the central part of the second Abbasid palace at Samarra, the Balkuwara Palace (854–859), and it has been suggested that the Ottoman kiosk is derived from the earlier building.

Medina Azahra (Madinat Al-Zahra) was built by the Andalusian caliph Abdal-Rahman III (912–961), reputedly in honour of his favourite wife Zahra. It

was a country residence built on terraces on the hillside some miles outside Cordoba, but survived for less than a hundred years before being sacked and destroyed. However writers have left wonderful descriptions of the place, showing it to have been built in the eastern tradition and to have been almost the size of a small town. The remains have been excavated in the present century and the audience chamber in pa restored. 91

Perhaps the most perfect example of Islamic architecture is the Alhambra, the work of two of the 95 Nasrid monarchs of Granada, Yusuf I (1333–1353) and his son Muhammad V (1353–1391). However it has been suggested that there was a 12th-century

palace on the spot to which the famous fountain in the Court of Lions should be attributed. The Alhambra has survived to the present day largely because it became a residence of the Christian kings of Spain who preserved it intact.

The palace was constructed in three units: the Meshwar (Spanish Mexuar) or public court, the formal throne room and court (the Court of Myrtles), and the harem or private apartments around the Court of Lions. As in many Muslim buildings the severe exterior of the Alhambra is in complete contrast to the fragile world of the interior, with its multiple needle-like columns and 'floating' stalactite ceilings.

The mausoleum

In addition to mosques and palaces the Islamic world has produced numerous other religious and secular structures – the madrasah (theological school) and the caravanserai (rest house on a caravan route) – as well as buildings which stand somewhat in isolation like the Dome of the Rock.

In the purpose and appearance, the mausoleum forms a separate category. Although Islam discouraged the erection of elaborate tombs this did not prevent rulers from building them, and in the east the mausoleum became the most important structure after the mosque and palace. Unlike the palace, vast sections of which were hidden from public view, the mausoleum was often built as a public demonstration of political power, a permanent celebration of a departed ruler's might.

The Tomb of the Samanids, Bukhara (10th century) The tomb consists of a small brick-built chamber covered by a dome. Structurally it forms a landmark in Islamic architecture, being one of the first examples of a dome fitted perfectly on to a square chamber by means of squinches. The building relied for its external decorative effect on extreme contrasts of light and shade, achieved by laying each alternate brick sideways so that there is a uniform pattern of shadow all over the surface. This idea influenced later architectural decoration throughout the Near East.

The Gunbad-i Qabus (1006–1007) This massive brick tomb, the largest of its kind, was built by a local ruler of Gurgan near the southern shore of the Caspian Sea. It is an immense circular tower, two hundred feet high, with ten buttresses and a pointed 'tent' roof. This is the earliest of some fifty tomb towers constructed in Iran, the majority of which are round, though octagonal and fluted ones occur.

The finest tomb towers (türbes) were built by the Seljuks of Anatolia. They are mostly stone structures with conical roofs and the majority are carved with floral and geometric designs. The tomb chamber proper is located in an underground crypt.

The Mausoleum of Oljetu (Ilkhanid 1307–1313) The mausoleum was built at Sultaniya, one of the Mongol capitals of Iran, initially with the intention of making it the shrine of one of the early Muslim saints, Imam Husayn. The huge dome rests on an octagonal base around which runs a gallery with arcades opening outwards. A simpler form of this had been used in the Samanid Tomb. On each angle of the octagon there stood a slender minaret, only the bases of which remain today. There are two domes, one inside the other, a low one covering the inner chamber and above that the high pointed one seen from outside. Double domes had already been used by the Seljuks, in the Masjid-i Jami' of Isfahan and also in tomb towers.

The Gur-i Amir (Timurid, 1405) Timur intended the Gur-i Amir at Samarkand to be the tomb of his nephew, but as he himself died in the year of its completion he was interred there too. Like the Mausoleum of Oljetu the dome is set on an octagonal base, but is raised on a tall circular drum. The bulbous dome is decorated with sixty-four flutes of blue faience tile. The interior chamber is square and richly decorated with semi-precious stones.

The Taj Mahal (Mughal, 1635) The Taj Mahal was the work of Shah Jahan, who built it for his wife. It follows the tradition of domed mausolea beginning with the Samanid Tomb, using a bulbous Timurid dome, and open galleries like the Mausoleum of Oljetu. The platform on which the tomb rests is a Mughal innovation and appears in the Tomb of Humayun (1565) from which the Taj Mahal is derived. Shah Jahan's own contribution was the use of white marble. The interior is lit through pierced marble lattices, while the actual tombs (for Shah Jahan is buried here too) are enclosed in an incredibly elaborate marble screen.

101 The Gur-i Amir, Mausoleum of Timur, Samarkand, 1405. Perhaps the most dramatic of the few remaining Timurid monuments; mausolea were often built as symbols of political power as well as serving as tombs. The bulbous dome with sixty-four volutes rests on an unusually high drum, a device used in earlier Timurid mausolea at the Shah-i Zindeh necropolis near Samarkand (about 1400). The lower tomb chamber is octagonal on the outside and square inside. The surface of the exterior is covered with inscriptions in simple geometric Kufic.

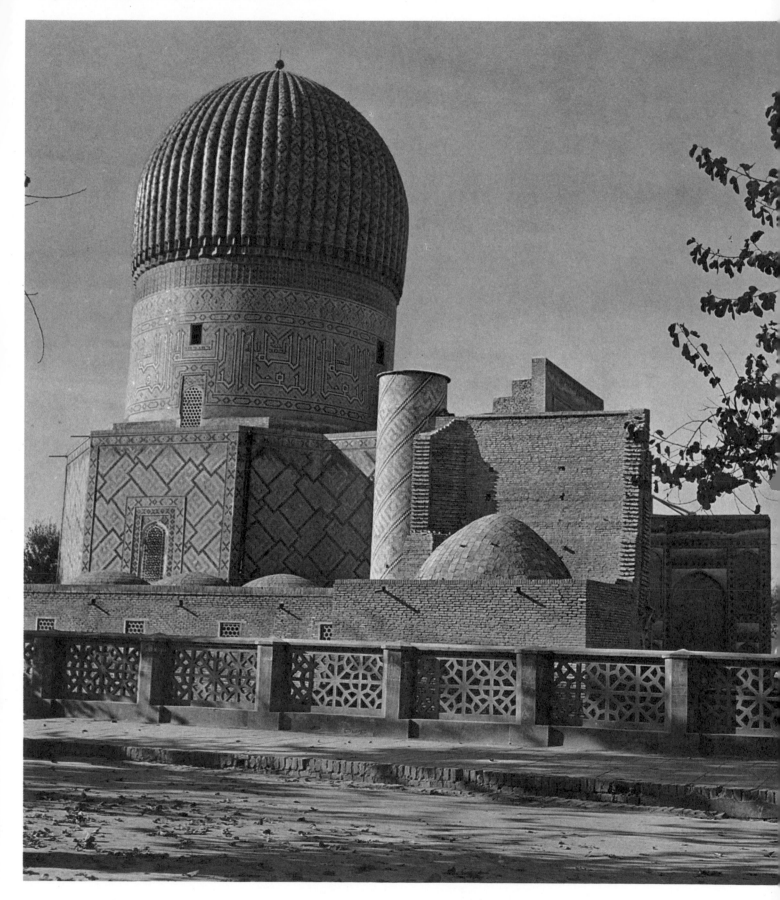

Glossary

Ablution pool All mosques have a pool or fountain for ritual ablutions before prayer.

Amir First used to mean an army commander, later it came to mean a prince.

Basmallah The phrase '*Bismillah al-rahman al-rahim*': 'In the name of God the Compassionate the Merciful'.

Diacritical points Dots above or below the characters of the Arabic alphabet to distinguish different sounds.

Caravanserai (Turkish Han) An inn on one of the great trade routes.

Gunbad A tomb or mausoleum.

Hammam A steam bath.

Ivan (iwan) A vaulted hall open on one narrow side. The greatest example is the Taq-i Kisra at Ctesiphon built by the Sasanian emperor Shapur I in the first half of the 3rd century.

Jami' A cathedral mosque.

Khamsah Quintet or five poems.

Lakabi ware Pottery in which the designs are carved or moulded with raised outlines to segregate the different coloured glazes. Used in Iran in the mid 12th century.

Lustre A glittering metallic glaze. Major discovery of Islamic potters and used constantly throughout the Islamic world from the 8th century onwards.

Madrasah A theological college.

Maghreb North-west Africa.

Manafi' Al-Hayawan 'The Usefulness of Animals', an Arabic work of natural science.

Maqamat Al-Hariri 'The Assemblies of Al-Hariri'. An exposition of the complexities of the Arabic language written in the form of humorous tales by Abul-Qasim Al-Hariri (1054–1122).

Masjid A mosque.

Mihrab A niche, or an indication of a niche, in the wall of a mosque facing Mecca.

Minbar A pulpit.

Minai ware Polychrome pottery of 12th- and 13th-century Iran which had to be refired several times. Some colours could not withstand the intense heat necessary to fire the pot and were added later and fused at a lower temperature.

Minaret The tower of a mosque from which the call to prayer is given.

Muzaffarids A local dynasty which succeeded the Ilkhanids in southern Iran (1317–1393).

Nama (Turkish Name) The Persian word for book.

Ortukids A local Turkish dynasty in the Diyarbekir area (1101–1312).

Sasanians The rulers of Iran prior to the Islamic conquest (AD 224–642).

Shah The Persian word for ruler.

Sultan Ruler.

Uzbegs A central Asian people whose most important dynasty was that of the Shaybanids (1500–1599).

Acknowledgements

Black and white photographs

Rolof Beny, Rome, 83 bottom; E. Boudout-Lamotte, Paris, 86, 90; British Museum, London, 45; Brooklyn Museum, 19; John Donat, London, 83; Hamlyn Group–Rex Roberts Studio, Dublin, 13, 23, 27, 30, 31, 49, 72, 73; Stephen Harrison, London, 9; A.F. Kersting, London, 64; M.A.S., Barcelona, 69 bottom; Metropolitan Museum of Art, New York, 8; Museum of Islamic Art, Cairo, 60; National Museum of Ireland, Dublin, 26; Antonello Perissinotto, Padua, 77, 91 right; H. Roger-Viollet, Paris 91 left; Smithsonian Institution, Washington, Freer Gallery of Art, 53; Staatsbibliothek, Berlin, 40; Staatlichmuseen, Berlin, 61; David Stronach, Tehran, 69; Edward de Unger, London, 12; Victoria and Albert Museum, London, 33.

Colour photographs

Bibliotheque Nationale, Paris, 15, 38; British Museum, London, 39, 58 top right; Camera Press Limited, London, 89; Cleveland Museum of Art, 42; J. E. Dayton, London, 6 bottom, 66 bottom, 81 top; John Donat, London, 85; Fogg Art Museum, Cambridge, Massachussetts, 10, 50, 51; Olga Ford, Leicester, 74 right; Paul Fox, London, 35 top; Fratelli Fabbri Editori, Milan, 62; Giraudon, Paris, 7; Paul Gotch, Shiraz, 66 top, 74 left; Calouste Gulbenkian Foundation, Lisbon, title page; Hamlyn Group–Rex Roberts Studio, Dublin, Frontispiece, 20 bottom, 24, 25, 32, 46, 47, 67, 71; Hermitage Museum, Leningrad, 20 top; Hispanic Society of America, New York, 75; Michael Holford, London, 11, 70 bottom left; A. F. Kersting, London, 6 top, 59; M.A.S., Barcelona, 63 top left, 78; McGraw Hill Book Company, New York, 35 bottom, 58 top left, 58 bottom left, 58 bottom right, 63 bottom, 70 top; Francis G. Mayer, New York 14; Erwin Meyer, Vienna, 17 top; Osterreichische Nationalbibliothek, Vienna, 28; Pierpont Morgan Library, New York, 43; Josephine Powell, Rome, 79, 93; Realities, Paris, 29; Scala, Florence, 17 bottom, 84; Smithsonian Institution, Washington, Freer Gallery of Art, 21, 34, 54, 55; Wim Swaan, New York, 88; Topkapi Sarayi Museum, Istanbul, 63 top right, 70 bottom right; Roger Wood, 81 bottom.

The line drawings in the text have been made by Hilary Richardson, Department of Archaeology, University College, Dublin.

Further reading

Arnold, Sir Thomas, *Painting in Islam*, Oxford University Press 1928, new edition Dover 1965.

Aslanapa, Oktay, *Turkish Art and Architecture*, Faber & Faber 1971.

Barett, Douglas, *Islamic Metalwork in the British Museum*, British Museum 1949.

Burckhardt, Titus, *Moorish Culture in Spain*, Allen & Unwin 1972.

Creswell, K. A. C., *Early Muslim Architecture*, Clarendon Press 1932–34.

Erdmann, Kurt, *Oriental Carpets*, Zwemmer, London, and Universe Books, New York 1960.

Ettinghausen, Richard, *Arab Painting*, Skira 1962.

Grube, Ernst, *The Classical Style in Islamic Painting*, Edizioni Oriens 1968.

Hoag, John D., *Western Islamic Architecture*, London 1963.

Lane, Arthur, *Early Islamic Pottery*, Faber & Faber 1958.

Lane, Arthur, *Later Islamic Pottery*, Faber & Faber 1959.

Pope, A. U., *An Introduction to Persian Architecture*, Oxford University Press 1969.

Wellesz, Emmy, *Akbar's Religious Thought as Reflected in Mughal Painting*, Allen & Unwin 1952.

Index

The numbers in bold type refer to illustrations

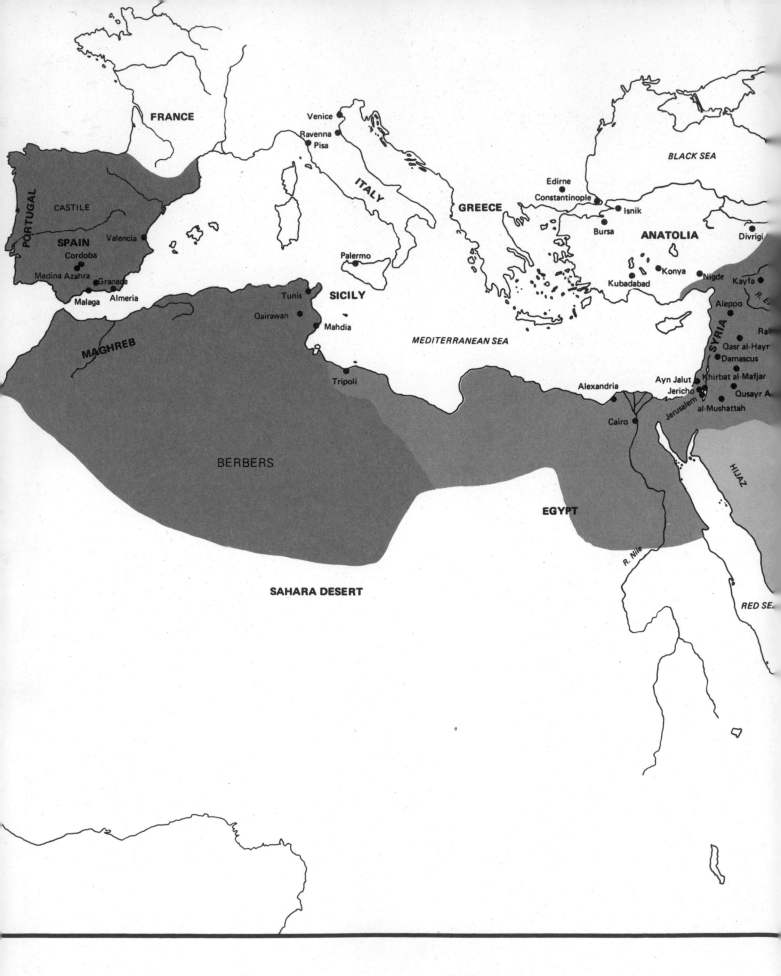

FRANCE

Venice
Ravenna
Pisa

ITALY

GREECE

BLACK SEA

Edirne
Constantinople
Bursa

Isnik

ANATOLIA

Divrigi

Konya
Nigde
Kayfa

Kubadabad

Aleppo

PORTUGAL
CASTILE

SPAIN
Valencia
Cordoba
Medina Azahra
Granada
Malaga
Almeria

SYRIA
Ra
Qasr al-Hayr
Damascus

MAGHREB

Tunis
Qairawan
Mahdia

SICILY
Palermo

Tripoli

MEDITERRANEAN SEA

Alexandria

Ayn Jalut
Jericho
Jerusalem

Khirbat al-Mafjar
Qusayr A
al-Mushattah

Cairo

BERBERS

EGYPT

R. Nile

HIJAZ

SAHARA DESERT

RED SE.

The Islamic Empire
from Spain to the borders of China
with principal sites mentioned in the text

Arabia at the time of Muhammad 622-632 AD